The DK Art School

AN INTRODUCTION TO
PASTELS

The DK Art School

AN INTRODUCTION TO
PASTELS

MICHAEL WRIGHT

DORLING KINDERSLEY
LONDON • NEW YORK • STUTTGART
IN ASSOCIATION WITH THE ROYAL ACADEMY OF ARTS

A DORLING KINDERSLEY BOOK

Project editor Emma Foa
Art editor Gurinder Purewall
Designers Dawn Terrey, Stefan Morris
Editorial assistant Margaret Chang
Series editor Emma Foa
Managing editor Sean Moore
Managing art editor Toni Kay
U.S. editor Laaren Brown
Production controller Helen Creeke
Photography Phil Gatward
Additional photography by Jeremy Hopley,
Tim Ridley

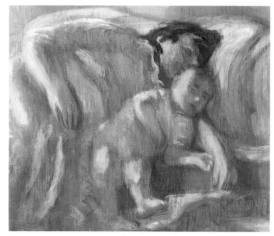

Norma Asleep with Baby Michael

To the patience and affection of my wife and family

First American Edition. 1993
2 4 6 8 10 9 7 5 3 1

Published in the United States
by Dorling Kindersley, Inc.,
232 Madison Avenue, New York, NY 10016

Library of Congress Cataloging-in-Publication Data

Wright, Michael, 1955-
An introduction to pastels/by Michael Wright. -- 1st American ed.
 p. cm. -- (DK art school)
Includes index.
ISBN 1-56458-374-0
1. Pastel drawing--Technique. 2. Drawing materials. I. Title.
II. Series.
NC880.W75 1993 93-19077
741.2'35--dc20 CIP

Color reproduction by Colourscan in Singapore
Printed and bound by Graphicom in Italy

CONTENTS

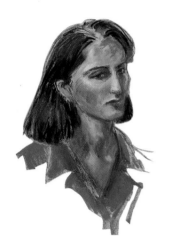

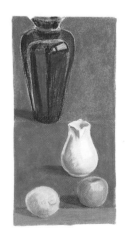

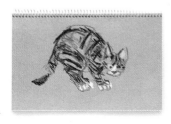

PASTEL

MANY ARTISTS CHOOSE to work in pastels rather than other painting media because of pastels' distinctive luminosity and ease of use. Pastel is unique in the way in which it combines the immediacy of drawing with a rich and painterly coloring power. It is ideal for a beginner wanting to make the transition from drawing and sketching into painting and equally valued by the professional artist who wants to develop an image simply and directly. Pastels are sticks of pure pigment that are made in a wide range of vivid colors and subtle tints. If you are using them for the first time, you may be surprised at how easily you master the essential techniques of handling them and the attractiveness of the imagery you produce. Pastels are suited to all types of images: they can capture a dramatic landscape or a quiet still life, a domestic scene or a moody portrait. Another advantage of the medium is that you don't have to organize a palette or prepare a painting surface before you begin work; there's no need for water or turpentine and no equipment to clean when you finish.

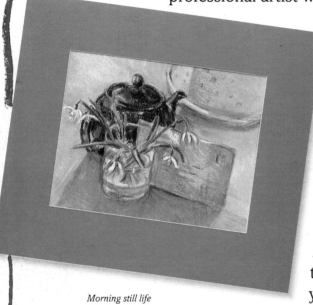

Morning still life

Range of colors

Because pastels are essentially dry painting sticks consisting of opaque pigment, they are not mixed in the ways that other media such as watercolor or oil paints can be mixed. Instead, manufacturers produce an enormous selection of colors for you to choose from. Pastels can, however, be mixed effectively by overlaying them or blending them directly on the pastel paper. This luminous, dry medium is easily effaced, reworked, and blended, allowing you to alter and develop a work without the complications of waiting for paint to dry.

One of the great advantages of pastel is that you can work quickly. It is perfect for catching the inspired moment, for translating transient images and spontaneous thoughts in full vibrant color. In addition, the portability and convenience of pastels make them excellent for working outdoors.

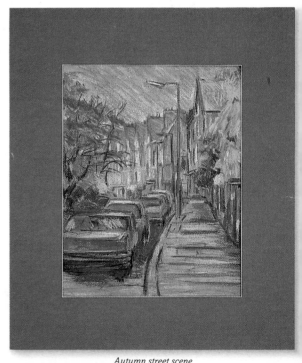

Autumn street scene

Far from being a fragile, delicate medium, pastel is as suited to large, ambitious compositions as it is to quick, lively sketches. You can develop it through many reworkings into vibrant layers or into a delicate surface of the most subtle nuances of color. The contemporary usage of the term "pastel" to describe light or soft colors belies the range and power of pastel as a coloring medium.

Pastel types

You can buy boxed sets of pastels or select your own colors. Before choosing an extensive range, you should explore the different types of pastel for their suitability to your needs and perhaps try one or two from the different manufacturers. You will find that the quality of each of the pastel types varies considerably between the various brands, and it is likely that you will have strong preferences for a particular shape, size, texture or quality of color unique to a certain color company.

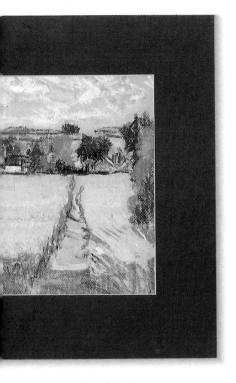

Peaceful landscape

Gaining in confidence

Depending on how you hold the pastel and how much pressure you bring to bear, you can draw fine, delicate lines or bold blocks of color. Held in your fingertips, pastel is responsive and sensitive to every movement of your hand. As you become more familiar with the medium, you will be able to achieve the most startling range of colors and textures.

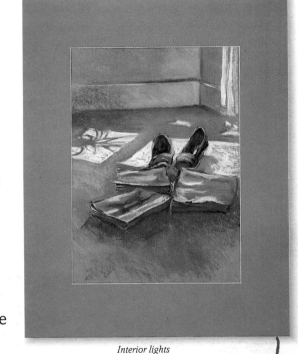

Interior lights

Getting started

The aim of this book is to introduce you to the pleasure of working with pastel and to show you the rich variety of materials and techniques available to the pastelist. The major differences between the pastel types are whether they are water- or oil-based and their varying soft, medium, or hard texture. Each pastel type has its particular qualities and suitability to a range of painting and drawing techniques, which will be explored through the following chapters.

Portrait study

BRIEF HISTORY

P ASTEL AS A PAINTING MEDIUM became popular in the 18th century – relatively late within the scope of the history of art. It had been used prior to this but primarily to heighten chalk drawings by giving them a greater range of colors. The form of soft pastel that we are familiar with today was first invented by a minor French artist, Jean Perréal, in the early 1500s. Although he used it to enhance drawings of Louis XII's military campaigns in Northern Italy, it is for his method of mixing pigments with a binding agent that he is chiefly remembered. In Italy Leonardo da Vinci *(1452-1519)* was quick to recognize the value of this new, dry coloring method and used it for some of his studies of the Last Supper. Artists could now work swiftly and easily in full color without having to wait for their paints to dry.

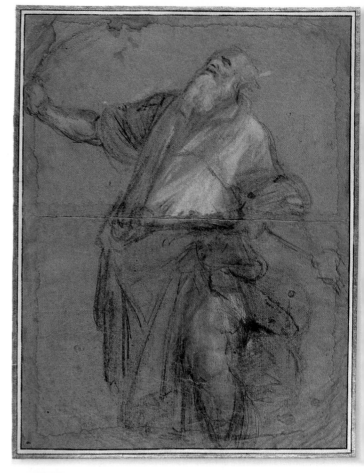

From chalk to pastel
A method of drawing that grew in popularity throughout the 17th and 18th centuries employed a "three crayon technique." This involved using black, sanguine (red), and white chalk, usually on a toned paper. Chalks had been the common graphic medium at the end of the 15th century. Portraits and studies, which were traditionally done in these three colors, gradually started to be executed with the addition of pastel. Around 1665, the French artist Charles Lebrun used pastel for a solemn, regal portrait of Louis XIV, thereby imbuing the relatively fledgling medium with a royal seal of approval.

The first artist to work exclusively in pastel was the celebrated Venetian artist Rosalba Carriera *(1675-1758)*. Starting her career by painting snuff-boxes, she graduated to painting portraits in pastels and found herself

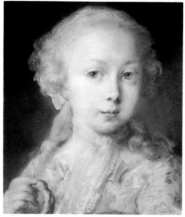

Jacopo Bassano, *Old Man Standing, Arms Outstretched, Contemplating the Sky,* **c.1575** *20 x 15 in (51 x 38 cm)*
This dynamic study of an old man is an example of "pastel-heightening," which was most commonly used in portraits throughout the 16th century. Black chalk on a blue ground has been worked with pink pastel, lending a greater realism to the drawing.

Rosalba Carriera, *Portrait of a Young Girl,* **c.1727** *13 x 11in (34 x 27cm)*
Carriera's portraits have a lightness of touch and an immense subtlety of blending. Here, she has used very different treatments to portray the girl's face, the hair, and the soft lace neckerchief.

in great demand both in Italy and France. Her paintings were mainly of high-born women and are characterized by a delicate style and a surprising air of spontaneity. Carriera was spectacularly successful and was invited to undertake portrait commissions in pastel throughout the major cities of Europe. In 1720, she traveled to Paris and is reputed to have painted no fewer than 50 portraits in that year alone.

The French artist Joseph Vivian *(1657-1735)* had already established pastel as a portrait medium in Paris, but it was Rosalba Carriera who exerted a tremendous influence on the painters of the day. Fellow artists clamored to see her work and emulate her style, and even years after her death her influence continued to be felt. It is estimated that by 1780 there were more than 2,500 pastelists working in Paris.

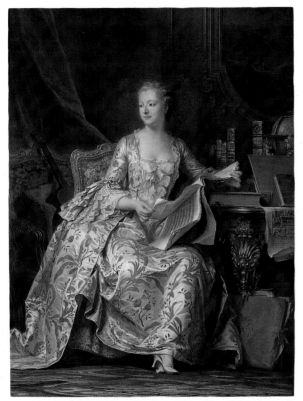

Jean-Baptiste-Siméon Chardin, *Self-Portrait in a Green Eye Shade*, 1775 *18 x 15in (46 x 38cm)*
Chardin worked in pastel in his later years, as a result of failing eyesight. This powerful work evinces a realism and sobriety quite distinct from the frothy portraits of his day.

Maurice Quentin de La Tour,
Portrait of Mme. de Pompadour,
***c.*1752** *70 x 52in (177.5 x 132cm)*
This exceptionally ambitious pastel work is testament to La Tour's consummate skills. An initial portrait of Mme. de Pompadour's face was produced on an oval piece of paper and subsequently glued onto the composition, which is constructed of several sheets joined together.

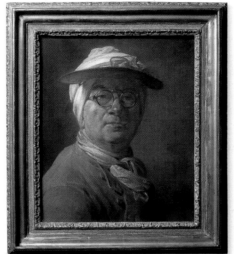

Quentin de La Tour

Of the many French portrait painters in the 18th century, Maurice Quentin de La Tour *(1704-88)* was one of the most brilliant; along with Jean-Baptiste Perroneau *(1715-83),* he was the most celebrated pastel portrait artist of his day. Converted to the medium by Carriera, La Tour pushed pastel to its technical limits. He prided himself on his ability to express the personality of his sitters, and indeed his portraits are characterized by psychological insight and a striking degree of animation. Speaking of his concern with the inner reality of his subjects; he commented, "I descend into the depths of my sitters and bring back the whole man." La Tour's sureness of draftsmanship made him the ideal artist to exploit the medium on a larger scale.

Other notable 18th-century pastelists are François Boucher *(1703-70),* who epitomized the fashionable frivolity and facile elegance associated with this period, and Jean-Baptiste-Siméon Chardin *(1699-1779),* who introduced new methods of building up color. It was Marie-Louise Vigée-Lebrun *(1755-1842),* however, who was the court favorite. In Switzerland, Jean Etienne Liotard *(1702-90)* was influential in his treatment of highly finished portraits in Eastern costume.

With the French Revolution, the world of the aristocracy and wealthy patrons who commissioned pastel portraits collapsed, and the great age of portraiture was closed. During the first half of the 19th century the use of pastel declined, finding favor with few major artists until Jean François Millet's *(1814-75)* surprising and powerful use of the medium to evoke melancholy rural landscapes.

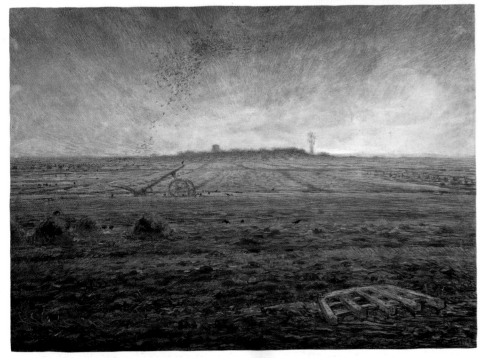

Jean François Millet, *Winter with Crows*,
1862-3 *28 x 38in (72 x 96cm)*
Millet's figurework relied on a monumental treatment of form in memorable images of rural labor. He also produced a series of landscapes without figures both in oil and in black chalk and pastel. This brooding and expressive piece is constructed out of small touches of pastel and is in striking contrast to the smooth treatment and blended form of the previous century, while foreshadowing the use of broken color associated with the Impressionists.

THE ADVENT OF IMPRESSIONISM heralded a new era for painting as artists started to focus on scenes of everyday life and experiment with capturing the effects of light. Pastel was a perfect medium for the Impressionists' aspirations toward a luminosity of color and a spontaneity of application. They introduced broken color effects using mixtures of primary and secondary colors juxtaposed in small strokes so as to blend in the eye of the viewer.

The towering figure of the early 19th century was Eugène Delacroix *(1798-1863)*, a brilliant colorist who exerted a strong influence on many of the younger painters. He had used pastel in preparatory sketches for large-scale studio compositions and also for studies of landscape. Eugene Boudin *(1824-98),* who ran a small stationery and picture-framing business in Le Havre, was so impressed by Delacroix's use of pastel that he began producing delightful scenes of the Normandy coast, catching the varying effects of light and weather. Boudin, in turn, exerted a considerable influence on Claude Monet *(1840-1926).* Camille Pissarro *(1830-1903)* and Berthe Morisot *(1841-95)* produced notable works in pastel, but the major exponents were Edgar Degas *(1834-1917),* Édouard Manet *(1832-83)* and Mary Cassatt *(1845-1926).* Degas did the most to extend the creative use of pastel, having worked consistently with the medium throughout his long career. He was a brilliant draftsman whose concern with the effects of movement led him to work from theatrical scenes, ballet dancers, horses, and images of women at their toilette, exploring expressive arrangements of the figure, often in artificial light.

The Impressionists were aided in their search for a new approach to composition by the possibility of cropping afforded by photography. Japanese prints were another major influence because of their unconventional arrangements and use of clear, rhythmical outline surrounding flat areas of color.

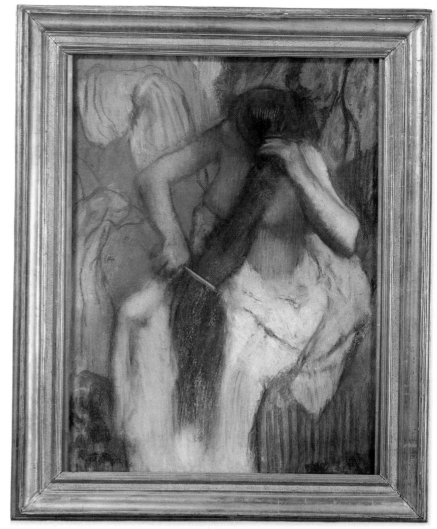

Edgar Degas, *Woman Combing her Hair*, c.1890-92 *32 x 22 in (82 x 57 cm) Degas' pastels are characterized by inventive design and a restless experimentation. He worked pastel with other media such as gouache, alternating between drawing and painting techniques in the same work. His approach was to build up the surface in rich layers of color by steaming the support and spraying it with fixative between applications of color.*

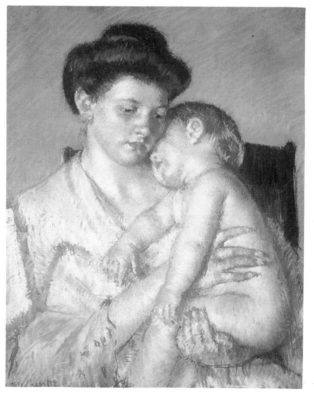

Mary Cassatt, *Sleeping Baby*, c.1910 *25½ x 20 in (64.8 x 52 cm) Cassatt, born in the US, later studied in Paris. Degas so admired her drawing skills and approach to composition that he invited her to exhibit with the Impressionists. This particular work is typical of her unsentimental but sensitive observation of her favored subject matter of mother and child.*

Into the 20th century

In 1870 the Société de Pastellistes was founded in Paris, and the first exhibition of the Pastel Society was held in London in 1880. Among the many major artists who have used pastel are Pierre-Auguste Renoir *(1841-1919)*, Henri de Toulouse-Lautrec *(1864-1901)*, Edouard Vuillard *(1868-1940)*, and James Whistler *(1834-1903)*. Vuillard produced a significant number of works in pastel, and Whistler executed a series of pastel compositions from the female figure and a number of landscapes.

A major exponent of the medium was Odilon Redon *(1840-1916)*, who progressed to pastel relatively late in his career, producing many rich, mystical scenes. The Surrealists of a later generation regarded Redon's imagery as a precursor to their own explorations of the subconscious.

Many painters of the 20th century have used pastel as an extension of drawing but less frequently as a painting medium. The most notable exception is the contemporary R.B. Kitaj *(b.1932)*, whose powerful pastel paintings are concerned with the human experience and address inner realities with beauty and pathos.

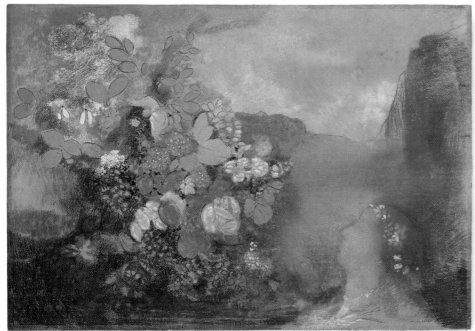

Odilon Redon, *Ophelia and Flowers, c.*1905-8
25 1/2 x 36 in (64 x 91cm)
Redon uses a recurring motif of a female head in profile. Here, it is placed alongside flowers in a dreamlike and evocative arrangement. If you view the painting from the right-hand side, it is immediately apparent that the composition began as a study of a vase of flowers. Redon subsequently turned the composition on its side and added the profile of the head.

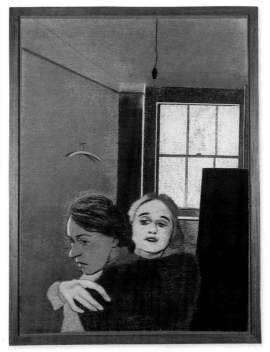

R.B.Kitaj, RA, *Study for the World's Body,* 1974
12 x 7 3/4 in (30 x 20 cm)
Kitaj is a highly respected painter and draftsman. He has worked consistently with pastel, both from photographic source material and direct from life. There is frequently a sexual or political tension at play between the protagonists that people his images of contemporary life.

Pablo Picasso, *Woman Seated at the Window,* 1937 *51 x 38 in (130 x 97 cm)*
Picasso used pastel at several stages in his career, but seldom to such a degree of finish as in this delightful work. He has built the image on a ground of red-brown which can be seen through the scumbled application of pastel. The dramatic use of lighting creates a tonal play between the positive shape of the wall and the negative shape of the window. The rounded forms of the figure are colored in primary and secondary hues, creating a playful quality which complements the sophisticated structure of the composition.

SOFT PASTELS

SOFT PASTEL IS THE ORIGINAL AND MOST popular form of the pastel medium. It is essentially pure pigment held lightly in a gum solution. Its soft fine-grained nature makes it ideal for painting techniques because of its ease of application, its surface-covering power and its amenability to blending. It provides you with an exciting breadth of surface qualities from delicate traces of overlaid colors to full, rich impasto. The first touch of soft pastel on paper reveals the beauty of the medium as the particles of pigment are dispersed and reflect light with a characteristic bloom.

THE TERM PASTEL comes from its Italian name *pastello*, a derivation of the word *pasta*, meaning paste. The name indicates the nature and style of manufacture of pastels, in which pigments are formed into a paste by mixing varying amounts of chalk and a light solution of a gum. The

The basic ingredients
Pastels are made up of dry pigments, precipitated chalk, and a binder such as tragacanth. The pigment is mixed into a stiff paste using a weak solution of gum dissolved in water. The chalk is added to the pigment in increasing proportion to create tints of the colors.

paste is then fashioned into sticks and left to dry.

Soft pastel contains just sufficient binder to hold the pigment in stick form and as a consequence retains the purity of hue of the original pigment. The tonal range of soft pastels is slightly restricted in the darker tones, but the artist is more than compensated by its extraordinary brilliance of hue.

There are a number of different companies that produce soft pastels of both artist and student quality. Artists' quality pastels use the finest pigments and are lightfast – they do not fade with time – and so they tend to be more expensive. A point to note is that soft pastels are not of a uniform consistency; you will find that, depending on the pigment you have chosen, some colors are much softer than others.

For example, some of the darker colors are considerably harder than the tints – the lighter versions of each color – which are uniformly soft. This is because the tints have a greater quantity of chalk in their makeup. It is therefore worth trying out the darker colors to test their relative softness.

Mortar and pestle

Boxed sets
Soft pastels are extremely fragile and must be stored carefully. A good solution is to buy boxed sets, as the pastels come in foam-filled trays. An added benefit of the foam compartments is that the colors stay clean. You can also buy empty pastel boxes with individual compartments if you prefer to make your own color selection.

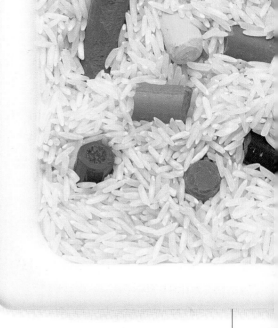

Of THE DIFFERENT pastel types – soft, hard, water-soluble, oil pastel, pastel pencil, and so on – soft pastel comes in the most extensive range of colors. Soft pastels are sold singly from cabinets or in boxed sets of various types and sizes. The very large sets have similarly impressive price tags. Some manufacturers produce more than 300 different colors.

Half pastels
These are sold in boxed sets of up to 60 and are favored by some artists for their shorter length.

Large pastels
Although quite costly, these chunky pastels are ideal for blocking in areas of color and for large-scale work. They come in a broad range of colors and are generally available from professional artists' suppliers.

Cleaning with rice
Soft pastels become dirty with use, making it difficult to recognize the different tints. It is good practice to clean them as you work by wiping them with a tissue. Alternatively, you can lay them in a tray of rice, which automatically rubs away the loose surface powder. Badly soiled pastels can be given a thorough cleaning by placing them in a jar of rice and gently shaking the jar up and down.

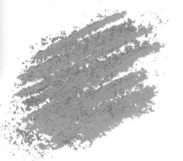

Pastel dust
By nature pastels are very soft and are likely to create a fine powder as you work with them.

Square pastels
Because of their sharp edges, these allow for more delicate lines than their round equivalents, but they are otherwise similar in their consistency and use. The color range, however, is more limited.

Blue over yellow
Here blue has been applied over yellow in broad strokes using the side of the pastel. Where the colors overlap they mix optically to create a green.

Making marks
Pastels allow you to vary your line by altering the angle of the pastel to the paper, by using either the edge, the tip, or the side of the pastel, or by changing the pressure with which you apply it.

OTHER PASTEL TYPES

A SURPRISING DIVERSITY of pastel types have been developed to accommodate a wide spectrum of creative uses. These "other" pastels are manufactured using similar fine ground pigments, but they are held together by different quantities or types of binding media. You can buy pastels in pencil form, and recent innovations have produced a water-soluble pastel that can be worked with a brush to create watercolor effects.

Pastel sticks can be either soft, medium, or hard, depending on the ratio of gum to pigment. After soft pastels, the most common type are hard pastels or Conté crayons. The brilliance of the color diminishes with the increase of gum, but the harder texture that makes this form of pastel ideal for detailed work compensates for the color loss. Hard pastels are more suited to drawing than painting techniques.

Similarities and differences
Hard pastel is compatible with soft pastel and is most commonly used in the early stages of a work when a certain degree of drawing is needed. It would then be overlaid with soft pastel. It is also used to put in fine line details in the latter stages of a soft pastel work.

Fine crayon mark
Hard pastels are square in section and can make a range of strokes, depending on how you hold them.

Crayons
These are medium-hard pastels that combine the facility for painting associated with soft pastels with the sharpness of line achieved by hard pastels. They come in a range of up to 80 colors and are popular for sketching and outdoor work as they are less bulky and less susceptible to breakage than soft pastels.

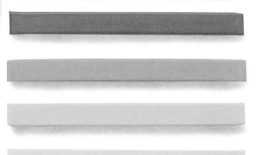

To aid detailed work, hard pastels can be sharpened using a blade, an emery board or small sheets of glass paper to gently pare the end to a point. When using the pastels, however, be careful not to exert too great a pressure since a sharpened hard pastel is likely to score the paper surface and reveal itself as a white line when you subsequently rework it with soft pastel. Conversely, it is also important not to fill the tooth of the paper with soft pastel as this prevents any further working with hard pastel.

Hard pastels come in a limited range of colors. Some makes have small amounts of black as an

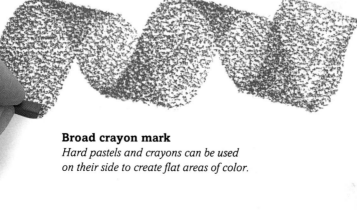

Broad crayon mark
Hard pastels and crayons can be used on their side to create flat areas of color.

additional constituent, which gives them a slightly darker tone than soft pastels. The limited range of colors means that you are required to engage in frequent color mixing directly on the paper if you want to achieve a subtlety of color. You can blend the colors by working them over one another in strokes using a close weave of marks to mix the different colors optically, or blend the colors with your finger or a stump of pastel.

An advantage of hard pastels is that they do not fill the tooth of the paper as readily as soft pastels. However, they do not have the textural range of soft pastel, and you can damage the paper surface trying to achieve a dense color effect. If you press too hard with a hard pastel you effectively burnish away the tooth of the paper.

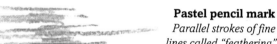

Pastel pencils
These are of the same consistency as pastel crayons, apart from being slightly softer and encased in wood. They are ideal for linear detailed work and can also be blended for delicate modeling of forms. Pastel pencils come in a range of around 80 colors. You can buy large boxed sets and replace the pencils as you use them or buy them singly.

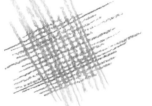

Cross-hatched marks
You can make fine lines with pastel pencils or gradations of tone if you increase the pressure.

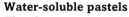

Pastel pencil mark
Parallel strokes of fine lines called "feathering" create a shimmering atmospheric effect.

Water-soluble pastels
These have a waxy consistency and can be used dry or wet. They are good for traditional drawing techniques but can also be washed over with a brush and water, transforming and softening the linear marks by dispersing the pigment into washes of color. Water-soluble pastels are sold singly and in boxed sets in a limited range of up to 48 colors.

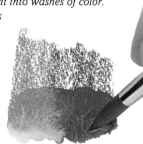

Washing over pastel

Water-soluble pastel marks
Depending on the amount of water applied, it is possible to vary the degree of dispersion. Water-soluble pastels are suitable for the technique of "line and wash." You can also achieve interesting rich color effects by drawing into a damp surface.

EQUIPMENT

A MAJOR ADVANTAGE OF working with pastels is their portability. Compared to other painting media, pastels are exceptionally straightforward to use. You will not need a palette to mix them on or thinners to dilute them. Usually the only equipment you will require are the pastels themselves, a support such as paper attached to a board, and the most subtle of all tools – your fingers.

In this respect pastel work is not dissimilar to drawing in its ease of use and utter simplicity of requirements. You can capture an image swiftly, anywhere, and in rich, velvety color. There are some additional tools and materials that you may be tempted to buy as you try the various techniques outlined in the following pages, but they do not cost a great deal and are readily supplied by most art supply stores.

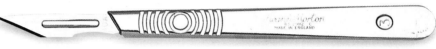

Scalpel
A scalpel is used for creating pastel dust for dry wash techniques (see pp. 52-3), for paring hard pastels down to a point, and for cutting paper and mounts. In oil pastel techniques, you can use a scalpel to scrape away color, to create lines in your painting, or to make changes.

Masking tape
This is used to mask off the edges of an area to be painted and for taping work to a board. Its particular advantage over other types of tape is that it peels away easily without tearing any fibers from the surface of a work.

Fixative
Pastel paintings can easily be spoiled by smudging. To prevent this you can spray fixative onto the paper to "fix" the pastel. Fixative is also used when you build up a painting in layers by means of spraying and fixing each successive layer of color. Fixative comes in large and small spray cans and is also sold in liquid form.

Mouth diffuser
Used with liquid fixative. Place the long end of the diffuser into the bottle of fixative and blow through the shorter end. It is far less convenient than the spray cans as you need to blow hard to have any effect. Take particular care not to inhale the fumes.

Sandpaper
Sandpaper is used to file the blunt ends of hard pastels and pastel pencils to a point for delicate linear work. You can buy small artists' pads of pastel paper from art suppliers; the idea is the same. If you purchase sandpaper from a hardware store, be sure to buy one of the finer grades.

FIXING YOUR WORK

Fixative is essentially a resin dissolved in solvent. As you spray your work the solvent evaporates leaving the resin on the support. This is what holds the pastel pigment in place. When fixing an image, make sure that you pin or tape the paper to a vertical surface rather than spraying it flat; this avoids the danger of large droplets falling onto your work.

Ideally, spray outdoors or in a well-ventilated but wind-free area, using a sweeping movement across the surface from the top to the bottom of your work. Be careful not to overspray your painting as the fixative is likely to alter the colors slightly, darkening them and making them lose their purity of hue.

Cotton swab

Small tortillon

Larger tortillon

Blending tools

Tortillons are the traditional blending tools for pastel work. They are tight twists of paper of various sizes. As you dirty the end you can peel away a layer of paper to create a clean point for further work. An alternative to tortillons are cotton swabs, and cotton balls can be used for blending larger areas.

Cotton ball

Erasers

There are a wide range of erasers on the market, most of which are unsuitable for pastel work. Soft and hard pastels can be erased effectively using either a kneading eraser or some soft bread. Oil pastel, however, cannot be erased with an eraser.

Brushes

Brushes are used for both applying and removing pastel. They are not as efficient as bread or putty rubbers for lifting off color, but they are effective for retrieving the tooth of the paper surface if it has filled up with pastel pigment. To do this, use a soft but firm watercolor brush and gently flick away the pigment. You can then rework the area with a new color.

Stiff short hair brush
This is used to blend soft or oil pastel into a support and for dry wash techniques in which you blend the pigment powder in. You can trim an old hog hair or stiff watercolor brush to achieve the necessary short length.

Hog hair brush
Some pastelists prefer stiff bristle brushes for making corrections on larger works. The method used is known as "dry scrubbing" and is as it sounds. These brushes are also used for moving pastel on the support with water.

Kneaded eraser
This type of eraser is highly suitable for soft pastel work and lifts color off easily. You can shape it into a point with your fingers so as to remove tiny areas of pastel pigment.

Watercolor brush
This is used to flick away pastel dust from the tooth of a pastel work, although it will rarely remove the pigment completely. Its springy fibers are suitable to delicate corrections and also to detail wet work.

Bread
Surprisingly, the most thorough eraser of all is bread. If you knead some fresh bread into a soft ball it will be ideal for erasing areas of soft pastel. Dry bread is unsuitable as it does not lift the particles of pastel from the fibers of the paper and may also scratch the surface.

Plastic rubber
This tends to smear a pastel work but is good for thoroughly cleaning the paper surface after you have lifted an area of pastel off by using bread or a kneaded eraser.

Wet wipes
These are a valuable addition to the studio and particularly practical when you are working outdoors. You can use them to clean your hands between colors and also to wipe down the pastels and minimize the amount of dust you inhale.

Tracing paper
Tracing paper or "glassine" are used to cover a pastel work and protect the surface from accidental smudging. Both are available from art supply stores.

OIL PASTEL

OIL PASTEL IS markedly different in character than other forms of pastel as the use of oil rather than gum as a binder produces a rich depth of tone and a distinct degree of transparency. Initially, oil pastels feel sticky against the tooth of the support. Their performance, however, is altered by temperature, and they become less sticky and move more easily over the surface of the paper as they get warmer. Just the heat from your hand will soften them, so it is a good idea to keep the wrappers on them as you work. They can be used on any paper or canvas support with a slight tooth and are frequently used on textured oil paper or board. Like oil paints, they can be modified by using turpentine.

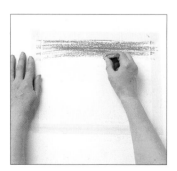

Seascape of softly blended colors

THE TOOTH OF THE PAPER surface soon fills with oil pastel and subsequent layers of color tend to slide on the surface. You can, however, make alterations to oil pastel in ways that you cannot with soft pastel. For example, you can scrape the oil pastel off with a blunt blade or work into it with turpentine or white spirit.

Fan of colors
Oil pastel comes in a less extensive range than soft pastel, numbering about 80 colors in all, but you can make subtle and attractive blends.

Blending two colors
You can see here that the oily texture of the pastel produces a transparent mix of red and yellow.

Pink blended into blue

Fine lines of color

LAYING A WASH

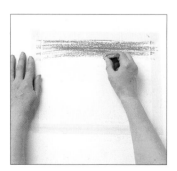

1 *Apply the oil pastel in an even and not too dense application across the surface of the support.*

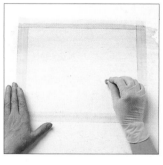

2 *Wearing a glove, dip a cotton ball in turpentine to disperse the color in a gradated tone.*

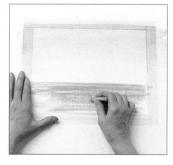

3 *Repeat the same procedure for the ground, laying in green in sweeping horizontal strokes.*

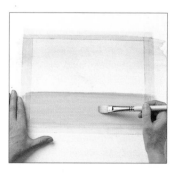

4 *Use a brush to apply the turpentine. This disperses the color without removing it.*

Techniques

Oil pastels can be worked in an exciting array of techniques. They can be thinned to create luminous washes of color, they can be blended, and they can be applied quite thickly to create an impasto effect. They are also ideal for the technique of "sgraffito" where you can scratch lines through a dense layer of oil pastel to reveal the underlying color that stains the support. Because they involve the use of turpentine, it is best to work on textured oil paper or oil board rather than use watercolor paper.

Stippling

This is a technique of applying pastel in a broken pattern of small marks to produce an attractive play of colors. The various colors then mix optically.

Materials

Cotton puff

Turpentine

Brush

Cotton swab

Penknife

Surgical glove

Oil paper

SOFTENING EDGES

The addition of white spirit or turpentine makes the pastel more malleable, and this can be used to great effect. For example, it is easier to mix colors on the support by blending one color into another or to soften the edges of an image with a brush or cotton ball, or to make more subtle transitions between tones.

1 *Lay a line of pastel around the edge of the flower to define the petals and accentuate their feathery texture.*

2 *With a cotton swab dipped in white spirit, go around the line to soften the mark. The cotton swab allows for precise blending.*

Impasto

The stiff texture of oil pastel makes it particularly suited to the dramatic effect of impasto, in which the pastel is pressed hard onto the support so as to leave a thick and opaque deposit of pigment.

Sgraffito

The technique of sgraffito is particularly effective in oil pastel. Here the artist has laid down bands of color to create a sky and then scraped through to the underlying tone with a blunt penknife.

Sgraffito

In this image, a thick, opaque layer of black oil pastel has been applied to the support and a blunt penknife has been used to draw into the pastel. The artist has scraped away lines to reveal the lighter tone of the support, achieving different tones by varying the pressure with the blade.

SELECTING COLORS

PASTEL WORK IS UNIQUE in that colors cannot be mixed on a palette in a conventional way. For this reason pastelists normally work with an extensive range of colors and tints. It is important to make a well-informed selection, as your choice will effectively become a ready-made palette of premixed colors. There are several ways to approach the selection of colors. You may find that a boxed set is entirely suitable to your needs. The smaller sets contain an adequate range of colors for sketching, but they can be frustrating when you cannot achieve a particular color that you want. If you intend to work with varied subject matter, it is preferable to select the widest range of colors. Ideally, you need a range of about 48 pastels to approach a broad spectrum of subjects with confidence.

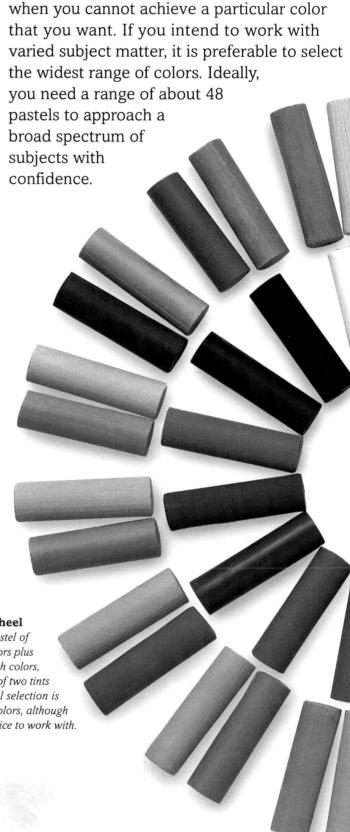

IF YOU INTEND TO MAKE your own selection of colors, you need to feel that you have chosen the optimum breadth without buying unnecessary ones. Manufacturers produce charts of their colors and tints which present a delightful but often bewildering array of possibilities – sometimes up to 300 different colors. When you look at a color chart or a tray of pastels in a store you will find that there are full-strength colors, each of which has an adjacent set of up to eight tints that move progressively toward white. Start by selecting from the full-strength colors, and then buy one or two tints of your preferred choices.

Color wheel

The inner ring contains a warm and a cool pastel of each of the essential primary and secondary colors plus a single mid-orange. In addition, there are earth colors, a black, and a white. The outer ring consists of two tints of each of the full-strength colors. The total selection is 48 pastels and represents a good range of colors, although you may well prefer to make your own choice to work with.

Range of greens

The different types of pastels are sold in boxed sets or singly from selection trays where they are usually arranged in ranks of tints of colors. Soft pastels are sold in the most extensive range; this selection of greens gives an indication of the wealth of tints available just for one color.

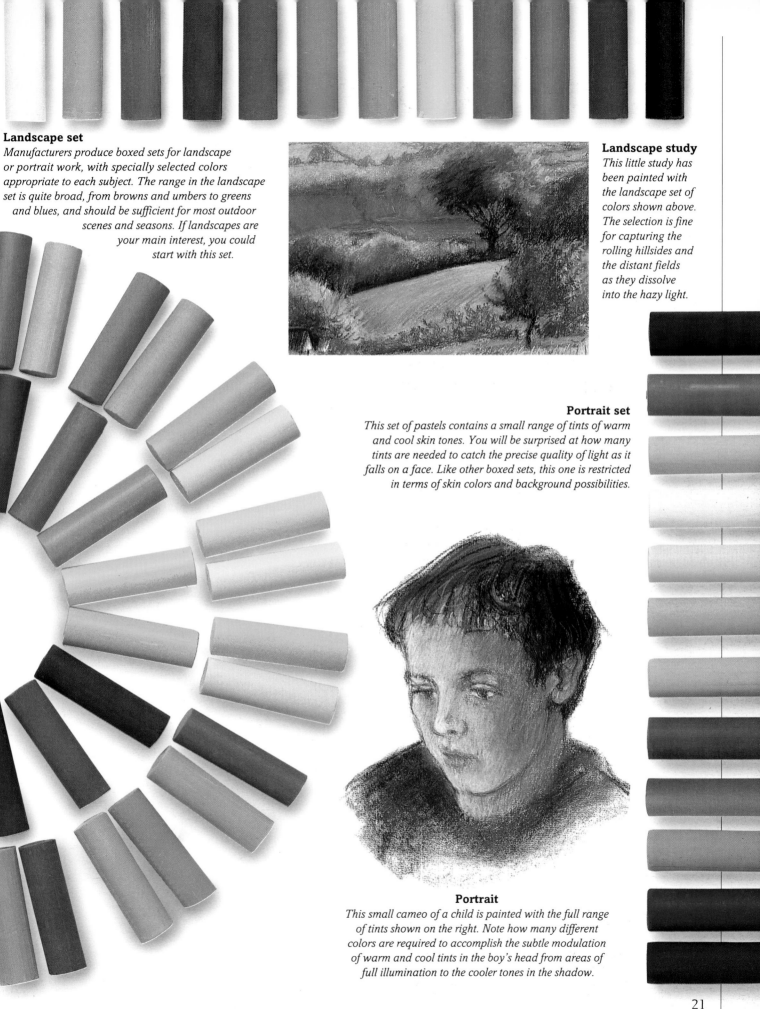

Landscape set
Manufacturers produce boxed sets for landscape or portrait work, with specially selected colors appropriate to each subject. The range in the landscape set is quite broad, from browns and umbers to greens and blues, and should be sufficient for most outdoor scenes and seasons. If landscapes are your main interest, you could start with this set.

Landscape study
This little study has been painted with the landscape set of colors shown above. The selection is fine for capturing the rolling hillsides and the distant fields as they dissolve into the hazy light.

Portrait set
This set of pastels contains a small range of tints of warm and cool skin tones. You will be surprised at how many tints are needed to catch the precise quality of light as it falls on a face. Like other boxed sets, this one is restricted in terms of skin colors and background possibilities.

Portrait
This small cameo of a child is painted with the full range of tints shown on the right. Note how many different colors are required to accomplish the subtle modulation of warm and cool tints in the boy's head from areas of full illumination to the cooler tones in the shadow.

GALLERY OF PASTEL TYPES

THE DIFFERENT TYPES OF PASTEL – soft, hard, oil, and water-soluble – have unique qualities that make them suitable to a particular range of techniques. In choosing one, the major consideration is whether you prefer the dry, powdery quality of the soft and hard pastels or the transparent, waxy colors of oil pastels and water-soluble pastels. Each of the works shown here has been executed with a different type of pastel, and together the paintings exemplify the enormous range of techniques which can be achieved.

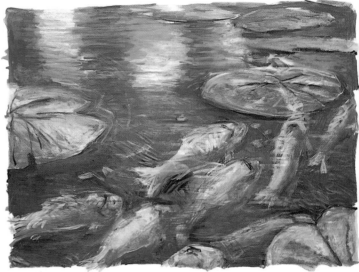

Ian McCaughrean, *Koi Carp* *9 x 13 in (23 x 33 cm)*
The watery qualities of this painting have been achieved by using water-soluble pastels. The artist developed the composition by drawing the forms of the carp and lilies in a linear technique and then hatching in areas of dense color. He then washed over the colors with a wet paintbrush, turning the areas of pastel into washes of color. Water-soluble pastels are similar in texture to wax crayons when dry but take on the quality of a watercolor wash when reworked with water. The transformation into wash is particularly evident in the yellow highlights on the fish and the reflections on the water.

Paul Bartlett, *Father Reading Sunday Newspapers*
17 x 25 in (43 x 64 cm)
In this carefully worked portrait of his father, Bartlett has used dry pastel and three shades of pastel pencils – pink, brown, and black – to capture the sense of light and shadow within the room. The suitability of hard pastels to a detailed drawing technique is evident in this powerful composition, which relies for its effect on the strong shafts of light falling across the forms of the interior. Note in particular the fine lines in the top left-hand corner. The artist has used a warm, mid-toned paper with quite a pronounced tooth to create this grainy sense of reality.

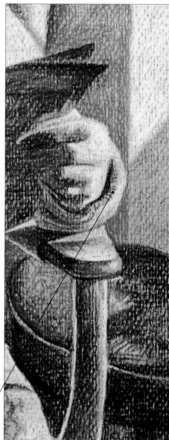

The artist could only have rendered this extraordinary degree of detail by using pastel pencils; soft pastels would have been totally inappropriate for capturing such fine definitions of line and tone. The artist's attachment to his subject is evident in the care with which he has drawn the fingers and cuff of the sleeve.

Odilon Redon, *Profile, the Flag,*
c.1900 *16 x 15 in (38.5 x 37.5 cm)*
In this very beautiful composition, you
can see the full range of techniques that
are possible using a combination of soft
and hard pastels or chalks. Redon has
employed a dark-toned chalk, honed to
a fine point, to define the profile of the
head, the eye, and the mouth, and to
cross-hatch around the face. A fine gold
highlights the headband and the nose
and cheek. He has achieved the rich
tones of the background, however,
by skillful blending of soft pastel.

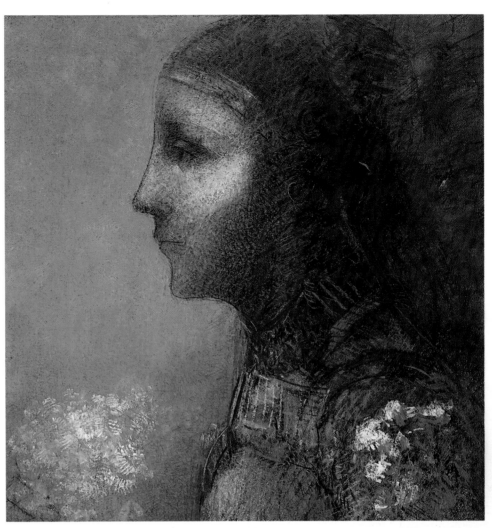

In this detail of the shoulder,
you can see the range of marks
Redon has employed, from the
fine lines of black chalk to the
open textural marks of the blue
and the pink. He has applied
the white more thickly, giving
the work a contemporary feel
of improvised abstraction.

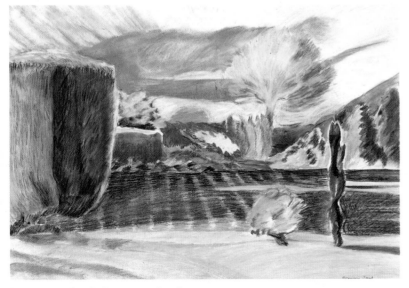

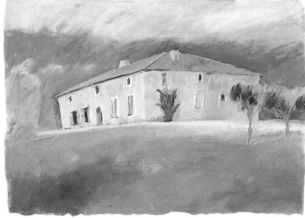

Jane Strother, *The Yellow House* *8 x 10 in (21 x 26 cm)*
The artist has created a highly dramatic composition in oil pastel
from the bold use of contrasting colors. The luminous tone of the
house is framed against the deep violet of the sky with its ominous
storm clouds. Strother uses turpentine to loosen the
oil pastel and create washes of color, as can be
seen in the broad sweep of red in the foreground.

Rosemary Saul, *Somerset Garden*
16½ x 23 in (42 x 59 cm)
This composition in pastel pencil presents a dreamlike
and surreal landscape. There is a dramatic interaction
between areas of light and shadow that invests the
forms with a sculptural presence. Saul has used pastel
pencils to blend warm and cool colors in a rich
weave of parallel feathered and hatched strokes.

In this detail you can see the way the artist has
combined the blending and drawing capabilities of
pastel pencil, relying on the point of the colored
pastels to create the range of textures and effects.

RANGE OF PAPERS

Canson paper

THE SUPPORT OR SURFACE YOU CHOOSE to work on is particularly significant with pastels because its texture and color will interact visually with the pastel colors, influencing your technique and affecting the appearance of the finished work. Paper, cardboard, and linen supports manufactured for pastel work have a distinctly textured surface that is referred to as the "tooth." This rubs away the pastel and holds the loosened pigment in its surface fibers. A wealth of supports are manufactured to suit the many different pastel types and techniques.

Flocked pastel cardboard

Watercolor paper

THE BEST QUALITY PAPER to work on is artists' quality watercolor or printmaking paper that is either hand- or machine-made. It is more expensive than ordinary paper but is heavy enough to sustain prolonged application of color. Such paper is usually embossed with the manufacturer's name and often has a watermark.

Pastel papers
For pastel work you need to choose a paper of artists' quality with sufficient tooth and weight to hold the pastel powder. Most watercolor papers are fine, but there are also papers which are specifically designed for pastel work. These are the Ingres and Canson papers that are sold as single sheets or pastel pads and come in an extensive range of colors and tints. They have a stippled or "laid" (ladderlike) texture of lines created by the manufacturing process of machine-rolling the paper.

Flocked pastel board

Tinted Ingres paper

Ingres paper

THESE HIGH-QUALITY PAPERS are made from 100 percent cotton rag. Unlike wood pulp papers, which rapidly become brittle and yellow with age, these are made without bleaching agents and will not change over time. Artists' quality paper comes in various thicknesses and is graded according to the weight of a ream, which is approximately 500 sheets of paper. Thin paper is about 72lbs (150gsm); medium 90lbs (190gsm). The heavier papers are 140lbs (300gsm) and above.

Some of the heavier papers are available in a rough surface that has a distinctly coarse grain. Smooth paper is generally unsuitable for pastel work since it lacks sufficient tooth.

You can also buy other types of supports for pastel work. Pastel board, for example, has a pronounced texture that is created by spraying fine particles of cloth onto the surface of the board. The flocked surface produces a softening effect on the pastel marks and is suitable for subtle blending effects. Another form of pastel board, often known as glass paper, has a fine layer of grit which has an exceptionally high degree of tooth. This is suitable to impasto work, in which thick applications of pastel are made.

Large sheets and rolls
Artists' quality paper comes in a range of sizes, from standard sheets to extra-large sheets – roughly 5ft by 4ft (153cm by 122cm). You can also buy 33ft (10 meter) rolls, either 30in (75cm) or 60in (150cm) wide, which can be cut to length for large-scale compositions. They are costly, so before buying a roll try out a sheet of paper of the same weight and texture.

Pads and books
Spiral-bound pads come in a selection of warm and cool tints and are very convenient for pastel sketching. You can try out different colored pastels on the various grounds to see which works best for your composition. The better quality books and pads have sheets of "glassine" separating the individual sheets of pastel paper. Glassine is a glossy paper that protects the finished pastel sketch by insuring against accidental smudging.

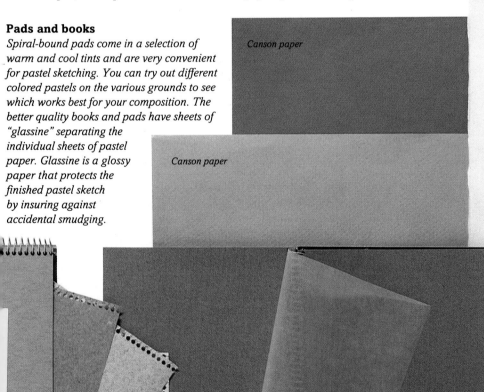

Canson paper

Canson paper

TEXTURES AND COLORS

YOU MAY BE SURPRISED at how the different textures and colors in supports can affect your paintings. You will need to select your support carefully to achieve the effect you want. The best way to gain a feel and an understanding of texture and color is to explore a simple subject composed of a few colors on a variety of different supports. You will notice that the same colors in your composition will be affected by your choice of background. One may really enhance the colors, while another may instead dull them. The different textures of your supports will also determine the way you apply the pastel.

THERE IS AN EXTENSIVE RANGE of textured papers and pastel boards for you to explore, from the soft surfaces that are almost like blotting paper, to the gritty surface of glass paper. Each of these surfaces is suitable for a particular range of techniques. An advantage of a heavily textured paper is that it will hold more pastel than a less textured one and allow you to build up a thick surface of color. A heavily textured support is tougher, so it is suitable for extensive overworking.

If you apply a pastel color lightly over a textured surface, the pastel will adhere to the high spots, creating tiny alternating particles of pastel that seem to sparkle. As you press harder you will achieve an even tone.

Watercolor paper
The even texture is suited to a more controlled blending than heavier textured papers.

Ingres paper
This is very popular, comes in an extensive range of colors, and has a pronounced texture of parallel lines.

Canson paper
This comes in an attractive range of colors and has a stippled texture on one side.

Textured paper
This fuchsia is drawn on a handmade watercolor paper. The impact of the image is rather feeble, as the white tone of the paper dulls the colors of the flower and the vase.

Flocked pastel board
This surface produces a softening effect which lends itself to subtle blending effects such as "sfumato."

Carborundum pastel board
The exceptional tooth on this makes it suitable for heavy impasto work, in which pastel is applied thickly.

Watercolor paper
Rough textured watercolor paper can sustain heavy treatment.

COLORED PAPERS ARE PRODUCED by many paper mills and vary in quality and texture. Look for artists' quality pastel papers; ordinary colored papers are likely to fade over time and may not have sufficient tooth to hold the pastel. There is a vast selection of subtle warm and cool tints that are generally used for pastel work as well as a delightful range of strong colored papers.

A colored support will harmonize or contrast with the pastel colors of your composition, creating either a dominant atmospheric tone or a unifying element in your painting.

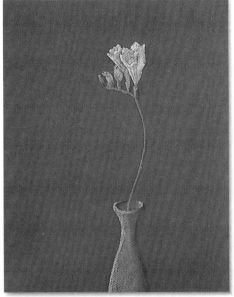

Mauve paper

This composition is similar to the one below: the dark tone of the purple makes the image appear luminous. The blue of the vase harmonizes with the support because they are both cool and purple contains blue. Purple also enhances the yellow in the stem and the flower.

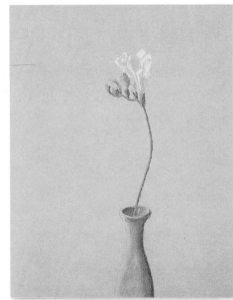

Peach paper

This image is not as dramatic as the other three, but it possesses a more subtle and less overbearing play of complementaries. The key to this effect is in the blue vase. The blue and the peach enhance each other, and the tone of the paper is dark enough to highlight the head of the flower.

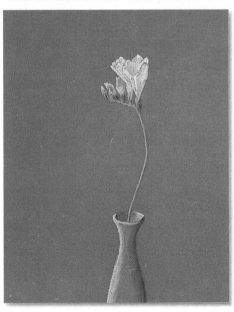

Red paper

This image is on vermilion, which is fiercely strident. The green of the stem almost appears to vibrate as the colors red and green are complementary and so mutually enhance each other. Complementaries can enliven a painting but they may appear crude if used to excess.

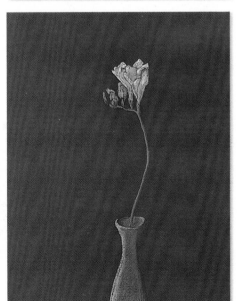

Green paper

This image is strikingly different from the image on white paper. The fuchsia is radically altered and appears luminous against the dark tone of the support. The olive green harmonizes with the lime green of the stem and throws the flower into sharp contrast against the melancholic ground.

TEXTURING PAPER

IT IS WELL WORTH EXPERIMENTING with texturing and coloring your own supports. You will be surprised at how simple the process is and what unusual, expressive effects you can achieve. Apart from the fact that you can create a far greater diversity of textures than those which are commercially available, you have the added benefit of being able to create exactly what you require for a particular subject matter or technique.

Both muslin and canvas can be stretched and glued onto board and make very stable surfaces with a strong texture suitable for pastel work. Alternatively, you can apply a layer of grit or sand or any other suitable material to board or paper using PVA glue or a gesso primer. These will provide interesting textures over which you can then add color by blending crushed pastel into the surface or by washing over it with a water-based paint.

COATING WITH GESSO is a very old method of preparing a surface for painting, and today's acrylic gesso is resistant to cracking and so is suitable for nonrigid supports such as canvas and paper. You can create an even and slightly textured support by applying gesso with a stiff hog hair brush. Paint a generous layer of acrylic gesso in downward strokes on the support. When this layer is dry, apply another layer in horizontal strokes. Alternatively, you can create a heavily textured surface by stippling the gesso onto the support in any configuration you choose. To create a textured surface with a greater degree of tooth you can mix powdered materials such as carborundum or graded sand into your gesso before you paint your support.

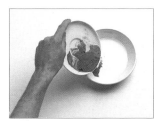

1 ▲ Tip orange pastel powder and fine carborundum into a dish containing acrylic gesso.

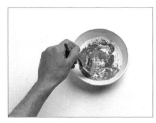

2 ▲ Start stirring the powders into the gesso with a stiff brush to gradually blend them in.

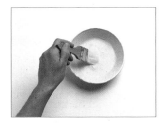

3 ▲ Continue working the mixture for a few minutes so that it attains the strength of the color.

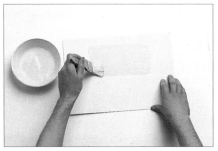

4 ▲ Apply the mixture in parallel brushstrokes across the surface of the support to create an even texture.

The textured paper after drying flat

Materials

Large bristle brush

Soft round brush

STIPPLED TEXTURED GROUND

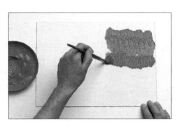

1 *A heavier texture is created by mixing a graded sand and a crushed dark brown pastel into gesso.*

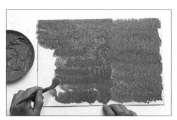

2 *The mixture is applied using a loaded brush in short, stippling motions across the surface of the paper.*

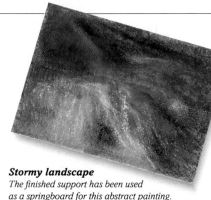

Stormy landscape
The finished support has been used as a springboard for this abstract painting.

FROTTAGE

Frottage is a simple technique for creating a textured pattern on paper. Place a medium to thin sheet of paper on a textured surface such as unplaned wood or a wall, and rub the side of a pastel across the surface of the paper as you would in brass rubbing. You can use different pastel colors to create a varied effect or take multiple rubbings using the same sheet of paper at different angles on the one surface. The frottaged surface of the paper makes an exciting ground for subsequent reworking and is an excellent stimulus to improvised abstractions. Frottage is also an ideal method of creating sheets of varied textures for use in collage work.

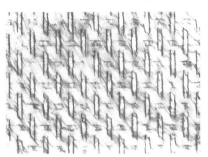

Frottaged wickerwork

Creating a textured support using carborundum

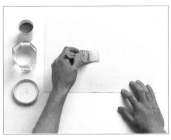

1 ▲ Dilute some PVA glue with water to make it more soluble and paint an even coat onto card- or art board with a wide brush.

2 ▲ While the glue is still wet, tip some carborundum powder into a small sieve and gently sprinkle the grit onto the surface.

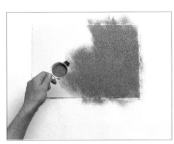

3 ▲ Continue sifting the powder over the support to build up an even texture. Don't worry if some spills over the edge.

4 ▲ Tap the support to remove the surplus powder and place the board under weights to stop it from buckling as it dries.

Materials

Orange pastel pigment

Sand

Carborundum powder

Sieve

PVA glue

Acrylic primer

Canvas

Muslin

Hardboard

Paper

Sand and grit supports
These three boards have been dusted with different grades of grit. The bottom one is carborundum, which is the finest, smoothest grade. The middle is a slightly grainier sieved sand and the top one is a coarser, unsieved sand which creates a less even texture.

Muslin and canvas boards
The bottom sheet is a manufactured linen board. The other two are handmade: the middle one has muslin stretched and glued onto board, and the top one has a fine-grained cotton duck canvas stretched and glued onto board. Both of these supports have been treated with an acrylic primer.

Textured and colored supports
These supports have been colored and textured using, for the bottom one, a crushed orange pastel brushed on with PVA. Next is a mix of crushed orange pastel, carborundum and gesso; then comes a support painted in crushed charcoal and PVA. The top support is two stippled patterns of brown pastel and gesso.

GALLERY OF SUPPORTS

THE DECISION YOU MAKE as to the scale, format, texture, and color of your support will make a major contribution to the impact of your composition. For example, a large scale allows you to engage in an ambitious treatment of a theme. Texture will influence the quality of the marks and control the way the pastel sits on the support. The color and tone of the support will create a note that runs through the composition, harmonizing with some colors and throwing others into sharp relief. As you will see, each of the artists in this gallery has capitalized on a particular quality inherent in their chosen support.

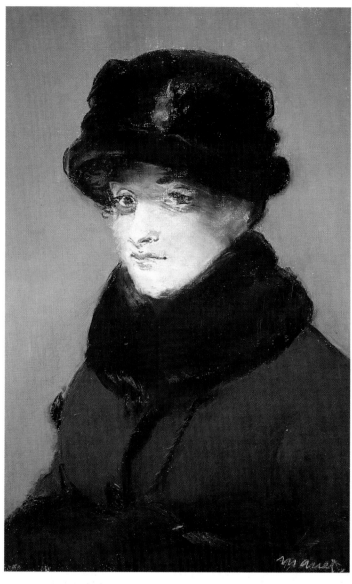

Portrait of Méry Laurent,
Edouard Manet, 1882 *21 x 13 in (54 x 34cm)*
Here, as in the majority of his pastel compositions, Manet has worked in soft pastel on fine-grained linen canvas. The texture of the support allows him to exercise his extraordinary skills in blending colors, since the tooth of the canvas gently holds the pigment. The treatment in this portrait is typical of Manet's use of a dramatic tonal range and limited colors. There is a beautifully observed play of light in the cool shadow cast in the manner of a veil across the luminous face of the sitter.

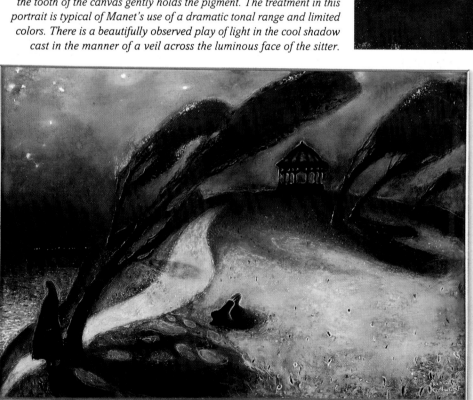

Richard Cartwright, *Clevedon*
Bandstand at Night *29 x 39 in (74 x 99 cm)*
Cartwright uses a black pastel paper mounted on cardboard and starts working on his images by blending soft pastel into the surface of the paper. Here he evokes the mysteries of night and the yearnings of a solitary figure.

To achieve the moonlit quality, the artist has applied pastel in a spectrum of techniques that includes blending, dotting, and sprinkling pastel onto the surface of the support.

Shanti Thomas, *Sleeping Woman,* *5 x 4ft (150 x 122 cm)*
It is possible to buy large sheets or rolls of watercolor paper
which are of sufficient weight and texture for extensive work in
pastel. Here, Thomas has used a full sheet to produce a portrait
of monumental scale. By making it nearly life-size she has
invested the figure with heroic proportions as testament to the
often unrecognized labors of women in their nurturing role.

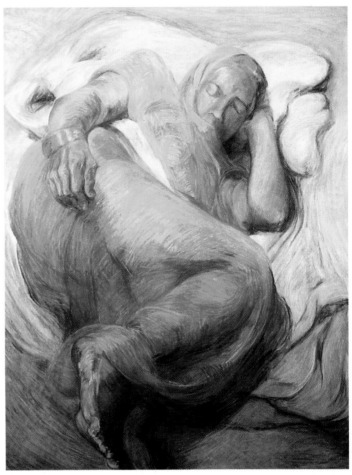

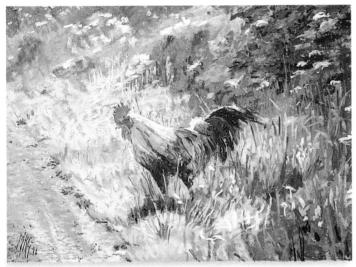

Margaret Glass, *Free Range* *9½ x 10 in (24 x 33 cm)*
The particular pastel paper used here is one which creates an even and
dense texture. Known as glass or flour paper, it has exceptional hold
and so is suitable to an impasto technique in which the color is built
up thickly. In this painting the support itself secures the image without
need of fixative, which lends the image its particular luminosity of color.

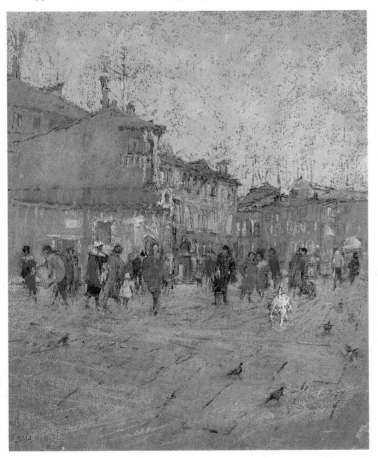

Diana Armfield, RA,
Campo S. Angelo, Venice, **1988** *9¾ x 8¼ in (25 x 21 cm)*
An accomplished pastelist, Armfield has relied on a warm-toned
paper to offset the rich blue note of the sky and to create the effect of
the sun's rays warming the buildings. She has left much of the paper
unpainted so that the hue of the buildings is due more to the tone of
the paper than to any overlaid pastel. The composition is organized
on the principle of complementaries – blues set against salmon-pinks
– and in the contrasting play of warm colors against cool.

In this detail the warm tones of the support shows through
the broken marks of the buildings, the figures, and the
paving stones, serving to link and unify the composition.

The movement
of the figures is
suggested by the
rhythm and angle
of the pastel marks.

Here, the figures are
visually linked to the
paving stones of the
piazza by the same
color range of cool
blue-gray notes.

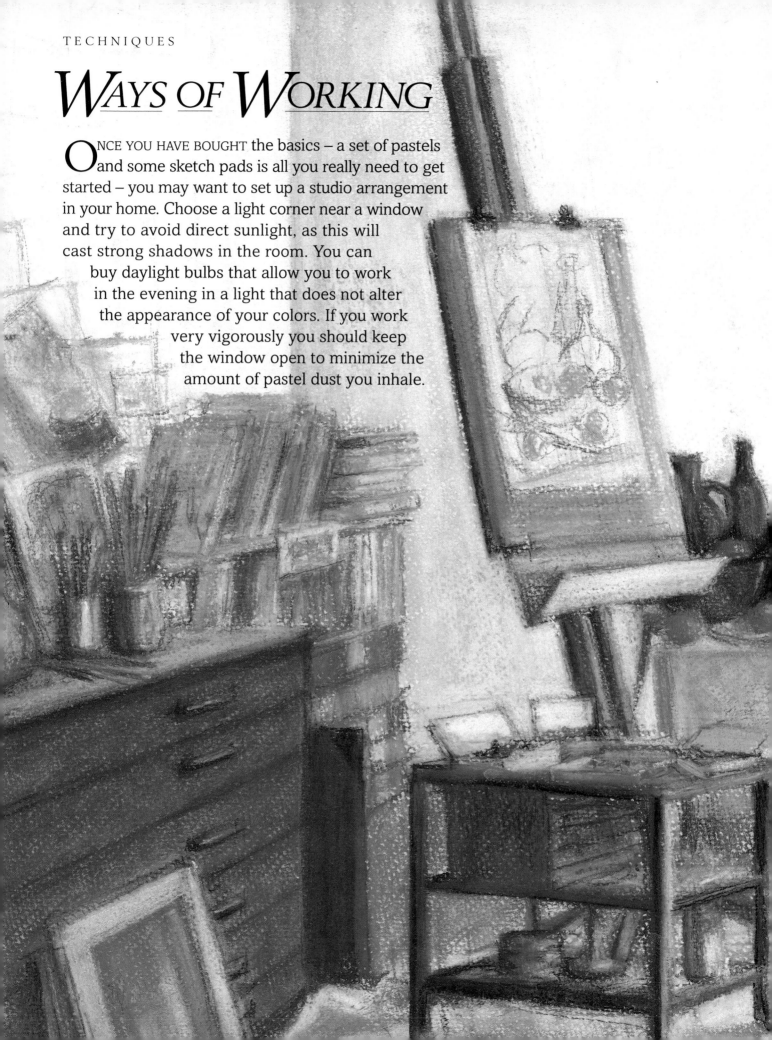

WAYS OF WORKING

ONCE YOU HAVE BOUGHT the basics – a set of pastels and some sketch pads is all you really need to get started – you may want to set up a studio arrangement in your home. Choose a light corner near a window and try to avoid direct sunlight, as this will cast strong shadows in the room. You can buy daylight bulbs that allow you to work in the evening in a light that does not alter the appearance of your colors. If you work very vigorously you should keep the window open to minimize the amount of pastel dust you inhale.

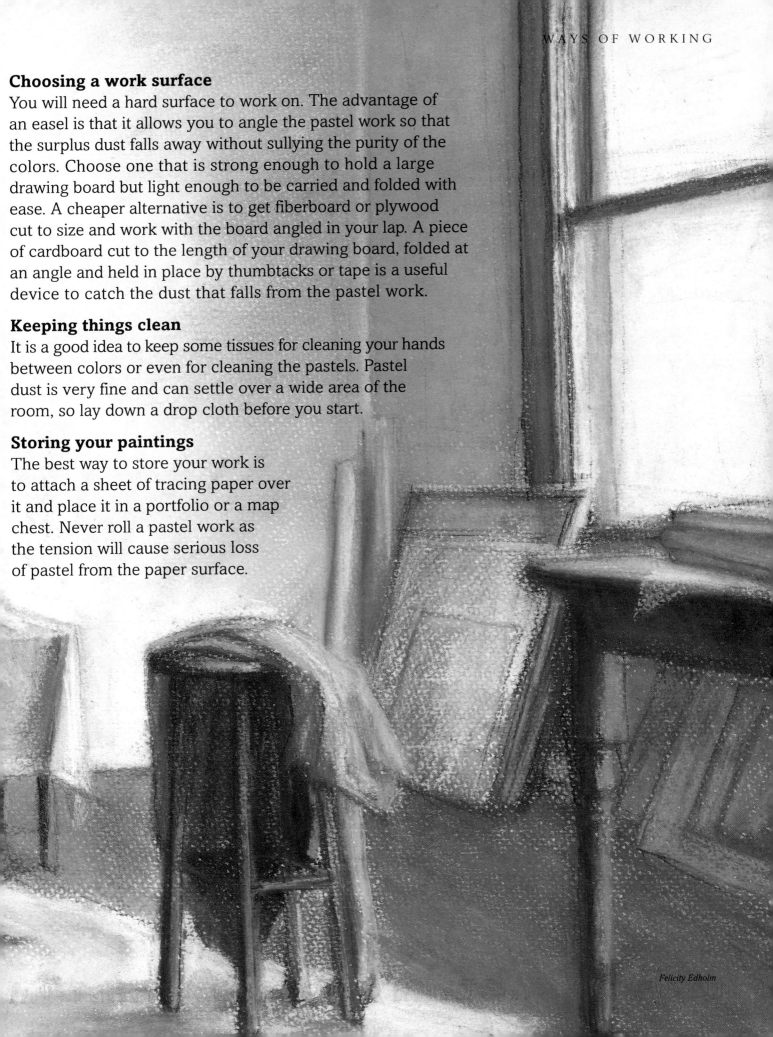

Choosing a work surface

You will need a hard surface to work on. The advantage of an easel is that it allows you to angle the pastel work so that the surplus dust falls away without sullying the purity of the colors. Choose one that is strong enough to hold a large drawing board but light enough to be carried and folded with ease. A cheaper alternative is to get fiberboard or plywood cut to size and work with the board angled in your lap. A piece of cardboard cut to the length of your drawing board, folded at an angle and held in place by thumbtacks or tape is a useful device to catch the dust that falls from the pastel work.

Keeping things clean

It is a good idea to keep some tissues for cleaning your hands between colors or even for cleaning the pastels. Pastel dust is very fine and can settle over a wide area of the room, so lay down a drop cloth before you start.

Storing your paintings

The best way to store your work is to attach a sheet of tracing paper over it and place it in a portfolio or a map chest. Never roll a pastel work as the tension will cause serious loss of pastel from the paper surface.

Felicity Edholm

CAPTURING AN IMAGE

THERE ARE SEVERAL techniques that you can use to capture an image, depending on the nature of your subject matter and how much time you have. As a general rule, it is better to start developing an image when you have the subject in front of you; however, often this is not possible. If, for example, you are trying to capture a child at play, your subject will be constantly moving. There are several ways of dealing with this, from making a series of quick sketches to taking photographs to use for reference later. Either method is fine, and you should practice them, either singly or in combination, so that you gain confidence in working in this way. When sketching from a changeable subject, choose a pastel pad that is big enough to develop a composition, and work with a limited number of colors. Try to select the most important features, as you will find that a few well-placed lines and colors will say a great deal about your feelings for what you are painting. The more you tackle different subjects, the more you will gain confidence in your ability to capture their essential character.

THE USE OF A CAMERA has a number of advantages, as you can photograph moving subjects in a rapid succession of shots and capture scenes that you would never be able to see with the naked eye. Also, a camera allows you to crop your subject using the viewfinder and make early decisions about how you wish to compose your final image. Alternatively, you may prefer to get ideas by cropping your finished photos in a variety of ways.

Series of snapshots

Cropping
An excellent method of developing a composition is to cut two pieces of cardboard into L-shapes to create a rectangular viewer. Use this to frame your subject or to crop a photo so as to achieve the most dynamic arrangement.

Greyhound racing
The painting is based on different views selected from the various photos. The fleeting passage of the greyhounds is expressed through the connecting rhythm of the legs, which contrasts with the blurred treatment of the shadows on the track and the surprisingly abrupt cropping created by the vertical edges of the support.

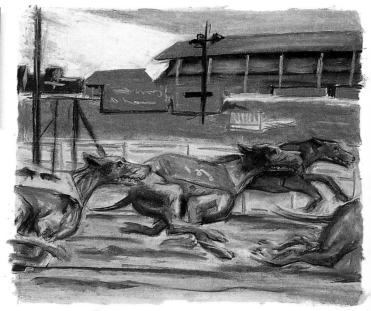

Blocking in

Working outdoors can be exciting but requires specific skills to catch an image in a particular quality of light when that light is constantly changing. You will find that you are forced to act decisively as you try to interpret a chosen scene. A good aid is to squint at your subject, which makes you focus on the major shapes and tones. Try this when you are working, and then block in the dominant tones in broad areas of color.

Working from a photograph

Initial blocks of color

Village street

Here the artist started by squinting at the photo to focus on the major shapes and tones and then did a preliminary sketch, blocking in the basic elements in broad areas of color. For the final image he chose to crop the left-hand edge off the photo and adapted and intensified the colors.

Sketching

Cats are ideal subjects for sketching, as they are capable of an extraordinary range of movements as they engage in their daily rituals of feeding, playing, and grooming. You will need to set down the essential shapes and relationships of the cat's form in rapid, decisive strokes. You can then work up a more finished painting by selecting the best of your sketches and either tracing your choice or copying it onto another sheet. Copying has the advantage that you can alter the size.

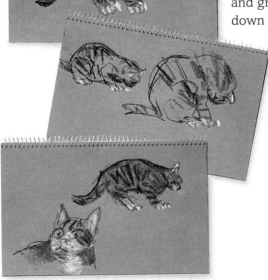

Quick sketches

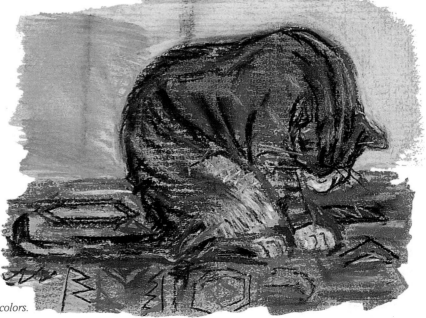

Sebastian grooming

The finished composition has the cat on his favorite rug, preening himself. The sketches, with their limited tonal range, have been transformed by a far more vibrant range of colors.

35

COMPOSITION

COMPOSITION FORMS THE HEART of painting. It is the art of organizing shapes and colors into a pleasing or expressive arrangement. When you look at a painting that you admire, you see a subject portrayed in a style that attracts you. More importantly, you experience the mind of the artist selecting, organizing, and inventing new shapes out of their subject. Successful composition requires a unifying theme – that is, a particular quality that recurs throughout the work, such as a dominant mood or visual rhythm. If you copy a subject faithfully, your composition will conform to certain predictable expectations – for example, the way gravity affects the objects in a room or how the quality of light is consistent. Deny these expectations and a composition soon takes on a disoriented feeling. However, we are easily bored by the predictable and often enjoy the surprise of unusual color arrangements or juxtapositions of shapes. Successful paintings frequently develop out of the search for both a recurring theme, which gives a work a sense of order, and a quality of the unexpected.

STILL LIFE is an ideal way to explore compositional issues. You can exercise complete control over the arrangement in a way that is not possible with other subjects. You can choose a specific range of colors to contrast or harmonize with one another; you can control the direction of the light, and you can position the objects in a variety of arrangements without fear that the set-up will alter while you paint. You will see that as you rearrange your chosen objects or alter the light or even view them from different angles you will immediately create entirely different compositions.

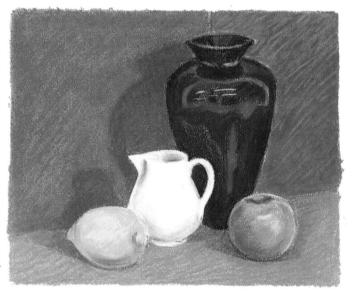

Standard view
Grouping objects is like the arrangement of players on a stage; each one will have its own character and will interact with the other players. Here, the vase dominates, creating the point of balance for the arrangement, while the surrounding forms echo one another in terms of shape and scale.

Horizontal arrangement
By translating a three-dimensional world of forms onto the two-dimensional world of the picture surface, you will create shapes that did not exist in your original subject. These new shapes are created by cropping and framing the subject by means of the vertical and horizontal edges of the support. In this horizontal composition, based on the format of a double square, the artist has invested the negative shapes between the positive shapes of the objects with as much interest and care as she has the objects themselves.

Balance

Consciously or unconsciously, we look for a balance of shape, color, tone, and directional lines within a composition. It is as if we place the painting on an imaginary fulcrum and intuitively find the balancing point. This is rarely in the exact middle of a painting but more often slightly off-center. Colors have different weights depending on how dark or how intense they are. For example, large, light, or weak-colored areas can be balanced by small, dense, and dark ones.

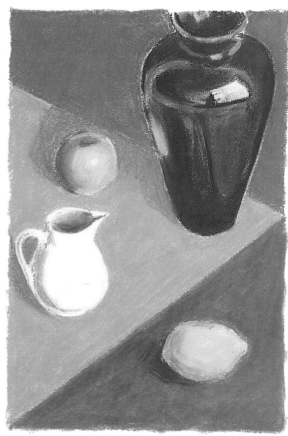

Vertical arrangement

Directional lines can create rhythmical connections within a composition and imbue it with a dynamic sense of movement and energy. Here the diagonal lines lead the eye on a zigzag route upward and across the width of the painting. They create a sharp impact that contrasts with the soft, rounded forms of the various objects within the arrangement.

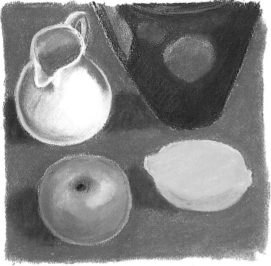

Square format

Colors affect us deeply. They can lift or lower our spirits and will have many physical and emotional associations for us: blue for sky and water, green for grass and growth, red for blood and heat, yellow for sun and daylight, white for the moon and night light. Here the bold colors of the forms, balanced within the square, sing out against the red ground.

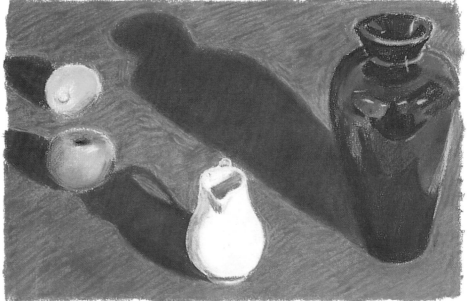

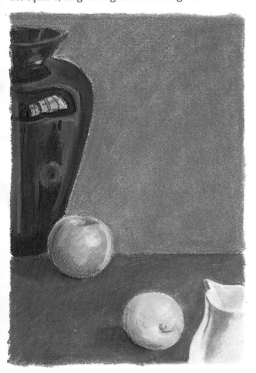

Vertical arrangement

The format of a support has a major impact on the way you arrange a composition. As a general rule, a vertical format is more dynamic and a horizontal format is more restful. Here, the artist has chosen a vertical format while striving for a sense of balance. She has placed her horizontal line across the lower third of the painting, instinctively recreating a visual formula known as the "Golden Section" that was considered aesthetically superior in the 19th century.

Arrangement with shadow

You can radically alter the appearance of a subject by changing the angle of the lighting or switching from daylight to artificial light. Here, a dramatic feeling of tension is created by the use of long diagonal shadows ascending from the base of the composition. The drama is increased by the steep angle of vision at which the objects are drawn. The theatrical lighting creates threatening and ambiguous shadows that invite imaginative interpretation.

GALLERY OF COMPOSITION

COMPOSITION IS ESSENTIALLY the art of selection and arrangement. The same subject viewed in a variety of ways will create entirely different compositions. One may seem balanced and generate a sense of calm while another may seem dramatic or even disturbing. For this reason, artists often paint a favored subject in a variety of ways. Composition requires you to be selective. It has as much to do with what you choose to leave out as what you choose to put in.

Blackburn blends pastel into the tooth of the paper, creating a rich surface of color that evokes a sense of light and atmosphere.

Divisions of fields and bushes are implied by luminous traces of lemon yellow and punctuating dark notes of deep blue.

The strong black lines suggest trees and saplings gripping the slopes of steep hills.

Joy Girvin,
Scala de Luce,
38 x 30 in (96 x 76 cm)
Girvin uses a vertical format, which amplifies the sense of enclosure created by the dense rhythm of the trees. The tangle of roots and branches creates a rich interplay of forms throughout the composition. The eye is drawn to the area of light along the diagonal line of the path as it winds its way through the cool shadows of the surrounding foliage to the promise of warmth and light beyond.

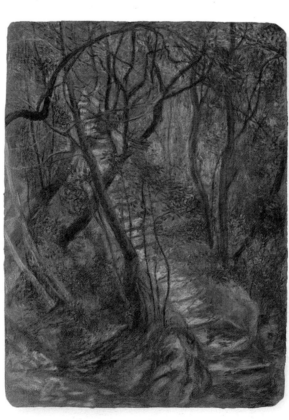

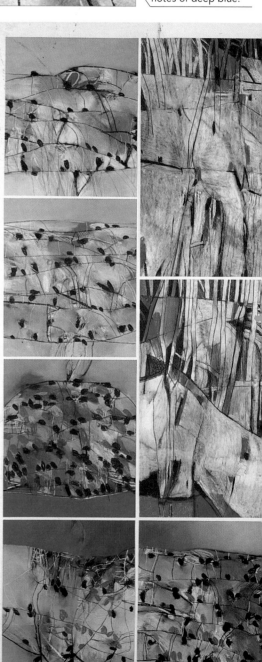

David Blackburn, *A Landscape Vision No. 7,* 1990 *60 x 65 in (153 x 165 cm)*
This highly inventive composition draws on memories and associations with landscape rather than portraying a series of literal views. The deliberate ambiguity engages the viewer in an imaginative interpretation not dissimilar to the experience of listening to music. The landscape is evoked rather than described as the mind reads the rhythm of shapes and colors, recalling experiences of journeys through woods and fields. The format is a symmetrical arrangement of rectangles forming a polyptych that has its roots in early religious altarpieces. Like an altarpiece, the image, with its small pieces clustering around the larger ones, seems designed as a focus for quiet meditation.

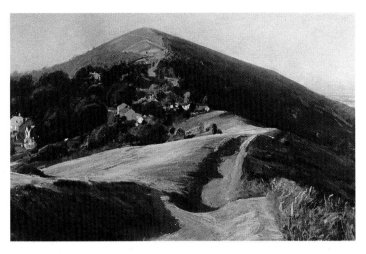

David Prentice, *Red Earl's Dyke, Malvern* *34 x 23 in (86 x 58 cm)*
Light transforms a landscape, creating atmosphere and visual drama.
The artist has made compositions from this subject through the changing
color and light of the seasons. This composition is constructed in a
striking, yet balanced, arrangement of contrasting shapes that amplify
the contours of the hill as it falls away from the afternoon light.

**The whiteness
of** the buildings
serves as a focal
point within the
composition.
Flat areas of
light balance
against the dark,
undulating sweeps
of the hillside.

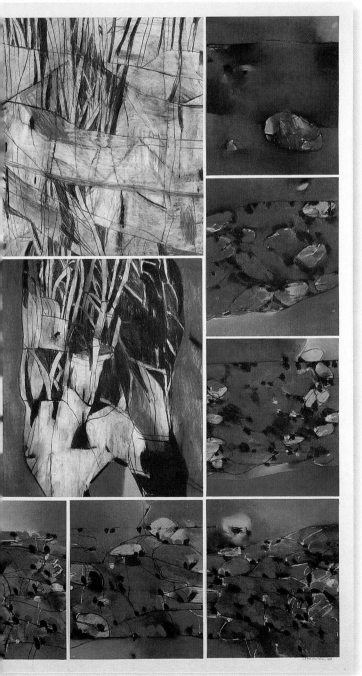

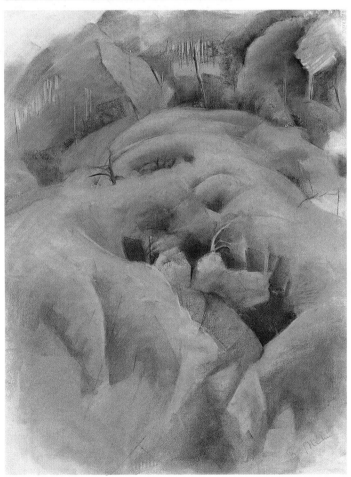

Bridget McCrum,
Autumn Landscape on the Dart *40 x 32 in (102 x 81 cm)*
Bridget McCrum is a sculptor who works from studies of animals.
In this powerful pastel piece, she has imbued the landscape with the
muscular flexings of a recumbent beast through the use of recurring
convex forms. The forbidding scale of the scene is implied by the
steep ascent of the orange and gold canopy of beech trees stretching
upward from the base of the picture. The forms merge and
separate, suggesting a hidden world beneath the surface.

SKETCHING WITH PASTEL

PASTEL IS AN IDEAL MEDIUM for sketching and is capable of an exceptionally wide range of mark-making. Depending on the pressure with which you apply the pastel to the paper, you can vary the texture of a mark from a grainy, faint trail to a thick line to a dense area of impasto. The expressive marks used in these sketches are created by a variety of gestures that do not attempt to copy the birds in precise detail so much as to record the artist's response to their mood, movement, and form. In this sense the act of sketching is a type of visual shorthand that translates the movement of the birds into an evocative language of lines and color.

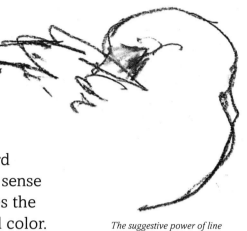

The suggestive power of line

THE DOMINANT USE OF LINE within a composition will lead the eye on a journey across and through the picture plane, and as a line is varied in pace, the eye of the viewer will automatically retrace the artist's response to the subject. For many people, linear marks have musical associations – lines can create a rhythm of movement and, depending on their strength or tension, can produce a sensation of energy or of relaxation. In addition to setting the mood, line acts as a boundary that defines shape. With practice you will be able to achieve an enormous variety of line simply by the way in which you manipulate the pastel. Hold the pastel with your fingertips, keeping the heel of your hand away from the paper surface so that you do not accidentally smudge your work.

A hint of color
There is a dramatic contrast created by the change in tone from the delicate light blue, used to describe the heads and bodies of the geese, to the black notes of their tail feathers. The complementary orange of their feet serves to root them quite firmly to the ground.

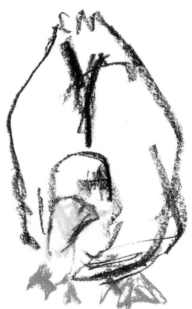

Defining form
This rapidly executed sketch has created a sense of energy, while the vigorous application of the marks suggests the presence of mass. Rather than simply outlining form, the curved lines imply the volume and solidity of the bird.

Foreshortened perspective
Even a few rapid lines can suggest a great deal about the character of a form. The perspective here allows you to imagine the ungainly gait of the bird as it waddles on dry land.

LINES DO NOT EXIST IN NATURE in the way that we represent them on paper; rather, they are an artificial device for directing the movement of the eye around the form of a subject and, depending on the character of the line, for suggesting qualities such as texture and mass.

As you work, you will find that you instinctively use the tip of the pastel to create fine lines and the side of the pastel to create areas of tone. You can suggest mass and volume by controlling areas of light and shadow so that you capture the way the light is falling on your subject. In addition, you can hatch or cross-hatch with the tip of the pastel to further define form.

Suggesting movement
This amusing sketch catches the raucous attitude of a bird competing for food. It relies for its presence on the strong, elongated lines of the neck, which appear to strain against the squatter form of the torso.

Line and color
Here color, particularly the use of white, adds to the sense of mass. The thrust of the parallel forms of the torsos and feet in these birds implies the angle of vision from which each was observed.

Thumbnail sketch
This little sketch shows how a sharply observed contour can be invested with a convincing sense of mass by the addition of color and tone – and also by the omission of color. The broken texture of the application of pastel to the back implies the luster of the feathers.

Building up the form
Here line and tone are combined to suggest the arrangement of feathers in the wings and tail. The neat, volumetric form of the torso, however, is encapsulated in the few loose, suggestive marks that define the bird.

Variety of marks
Note the soft treatment of the top of the duck's head compared to the bold, curved outline of its body and the sharp, angular lines of its webbed feet.

41

SKETCHING WITH TONE

TONE REFERS TO THE DEGREE of lightness or darkness of a surface. To work tonally is an approach totally different from one relying largely on line, since it is all about describing forms in terms of light and shadow. Tone defines the surface qualities of a subject as it is affected by light. A particular feature of tone is the way it unifies a composition.

As light falls into a space, all the forms will be unified by a similar degree of illumination and shadow, and this is referred to as the "tonal key" of a composition. A good way of understanding this tonal key is to squint or half close your eyes as you look at a subject. What you will see are tones rather than sharply defined details. Most artists do this instinctively as they paint in order to see the underlying tonal relationships in a situation.

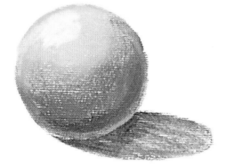

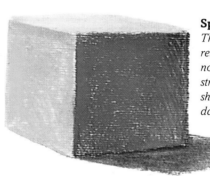

Sphere and cube

The best way to gain an understanding of tonal relationships is to work from simple forms that have no distracting surface patterns. Place the forms in a strong light source so as to create clear areas of light and shadow. Squint hard at each shape and use a single, cool, dark color to block in the shadow on the forms and the cast shadows. Compare the relative depth of each tone you lay in and build the forms out of the gradations of light and dark tone.

1 ◁ For this composition, use a warm, light-toned pastel paper which will serve to heighten the sense of sunlight. Start with cool, light colors and block in the main shapes of the room with the side of the pastel. Use an ice blue to define the edges of the windows, then a pale lilac to delineate items of furniture.

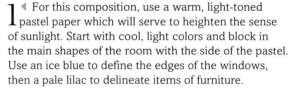

2 ▷ Gradually adding darker tones, build up blues, greens and purples, working over the image as a whole. Use the side of the pastel for broad areas and the tip for darker, sharper lines. The illuminated areas of the scene should be left unpainted so that the warm tones of the paper create a unifying sense of light.

3 ▲ Switching to a deep plum color, draw in the outline of the chair and start blocking in the window seat. As you strengthen the tones, you will automatically increase the sense of sunlight pouring in through the windows.

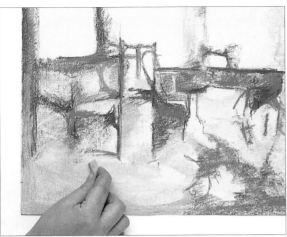

4 ◄ To capture the feel of the strong morning sunlight, start adding light, warmer tones to the painting – oranges and pinks and purples. Draw a pale peach color along its side to block in the areas of sunlight that are striking the floor.

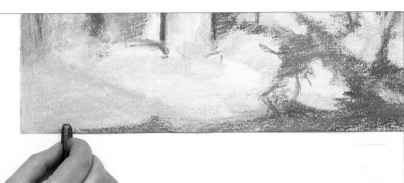

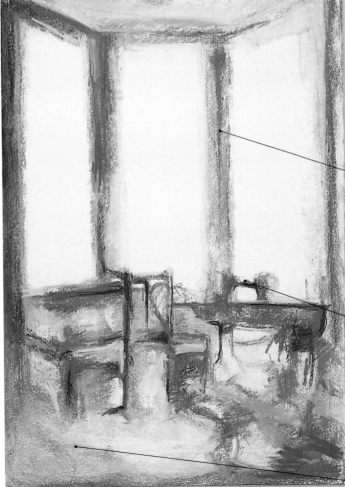

5 ◄ You can alter the mood of the room by adjusting the colors or modifying the various tones. Here a warm, grassy green is overlaid onto the blues, pinks, and purples to give this rich blend of colors. The effect is to create a hazy, atmospheric painting rather than a literal rendition of an interior.

6 ◄ Always mindful of how the light strikes the objects in the room, continue to build up the areas of light and shadow. Use a rich blue to strengthen contours and deepen the tone of the shadows in the foreground. The addition of this blue helps to frame and balance the image.

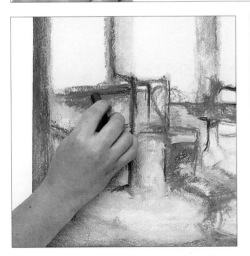

7 ▲ Although essentially a tonal study, the addition of line helps to sharpen certain forms. Here you can draw a very fine line with the edge of the pastel to help define the window seat and the chair.

Morning light

This tonal study explores the way that strong directional light determines the appearance of form, dividing the room into distinct shapes of light and shadow. The unpainted areas of the paper establish a recurring note for the sunlight as it floods the room.

Tamar Teiger

The shadow of the window frame and wall travels uninterrupted through the furniture onto the floor of the room.

The sewing machine is silhouetted against the light of the window, its tone and form contrasting sharply with the tone of its surroundings.

Light imparts a degree of warmth to all the surfaces it falls on, as in the color of the floor. The colors of the shadows here are conversely cool.

BLENDING

PASTELS DIFFER FROM OTHER PAINTING MEDIA in that they have to be mixed directly on the paper rather than in a palette. The pastel artist has several methods to choose from to achieve new colors. The most straightforward of these is simply to blend them. Blending is a technique of rubbing and fusing two or more colors on the surface of the paper into a unified tone. To do this, you can use your fingers, the side of your hand, or a blending tool, depending on the scale you are working in and which method you prefer. The pastel dust is held quite loosely by the tooth of the paper so that it is easy to spread adjacent colors into one another in this way.

Watermelon

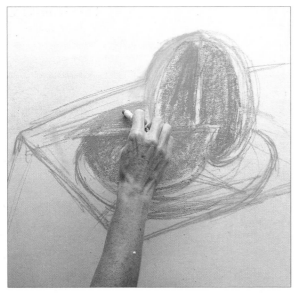

2 ◀ Blend in the flesh of the watermelon with your finger. Rubbing the surface in this way will distribute some of the loose pastel pigment over the paper.

1 ◀ Looking closely at your still life, sketch in the outlines of the watermelon, the platter, and the tablecloth using a yellow ochre soft pastel. Next, start blocking in areas of color using broad, loose strokes.

3 ▲ Continue to build up areas of color with loose strokes. Here, a pink pastel is used to add richness to the underlying color and to physically blend it in.

BLENDING TOOLS

Tortillons are the traditional tools for blending pastels. A tortillon is a tight roll of paper shaped like a crayon. You can use either the tip or the side to move and blend the pigment powder. Although tortillons afford a high degree of control, many artists prefer to use their fingers since the fibrous nature of tortillons – and similarly of rags and cotton swabs – tends to lift off some of the color instead of just blending it.

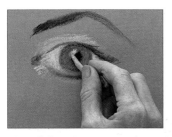

Kneaded eraser
Soften a lump of eraser in your hands and work it into a point. This forms a very fine blending and erasing tool, able to move tiny areas of pigment around or to lift pigment off completely.

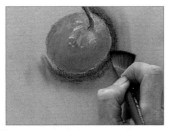

Brushes
Soft brushes are good for larger areas, particularly where the desired effect is a gradual changing of tone. They can be used to disperse the loose pigment particles or to lift the color off.

Tortillon
Available in two sizes, the tortillon is useful for softening the edges of an image although it may also remove some of the pigment. When it gets dirty, unwind some of the paper from the tip.

Soft cloth
A soft cloth can draw pigment across the paper and so is ideal for altering larger areas of pigment or, as in this case, for forming wispy white clouds on a blue background.

4 ▲ Lighten the area closest to the rind with a cotton ball. Its fibrous nature will lift off some of the pastel.

5 ◄ Continue to work over the piece as a whole. After sharpening the contours of the platter and filling in broad areas of the tablecloth, you can concentrate more on the folds of the cloth, particularly the crease made by the edge of the table. Make a bold wavy line along this edge; once you rub along it with your finger or a tortillon it will soften considerably.

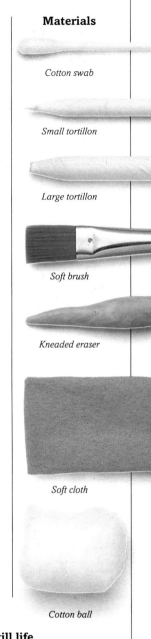

Cotton swab

Small tortillon

Large tortillon

Soft brush

Kneaded eraser

Soft cloth

Cotton ball

6 ▲ After adding the seeds, draw a line along the center of the melon. Run your finger along the line to gently blend that color into the surrounding area.

7 ▲ Using the side of the pastel, draw a broad white line to delineate the rim. To soften it, go over it with a cotton swab. Its size makes it ideal for working on small areas, allowing you more control than your finger would.

Note how blending the brown line at the point where the slice has been cut has dispersed some of the loose pigment into the pink, creating a greater sense of form and depth.

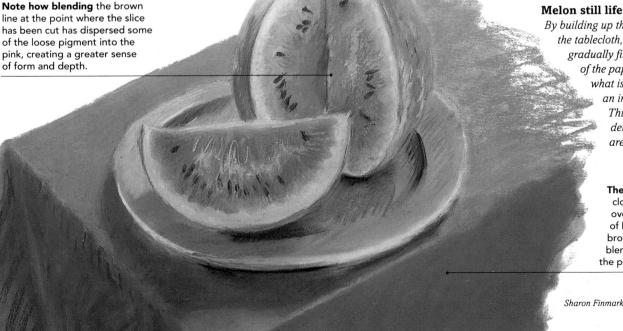

Melon still life
By building up the colors in the tablecloth, the artist has gradually filled in the tooth of the paper, creating what is known as an impasto effect. This creates a dense, unbroken area of color.

The rich color of the cloth is created by overlaying a range of blues, purples, browns and reds and blending them in with the pastels themselves.

Sharon Finmark

WARM TINTS, COOL SHADES

MODELING FORM REQUIRES an awareness of light and shadow, and an understanding of warm and cool colors. Just as you can divide up the different areas of a form into distinct light and dark tones as the form moves in and out of the light, so, too, you can divide a form into areas of warm and cool hues. The color of a form as it is perceived in an even white light is called the "local color." We rarely see a form in its true local color; what we see is how the form appears in a slightly colored light. Daylight and more extremely artificial tungsten light are generally biased toward yellow. This means that

as light falls on a form it will influence the local color and produce a yellowish cast. Conversely, the areas of local color in shadow will appear cool and biased toward blue-violet. When you are painting outdoors, the effect of light is particularly noticeable – you will find that the quality of light alters dramatically over a period of time, totally transforming what you see. Here, the artist has produced two portrait studies, one in direct frontal light and one in oblique lighting, exploring the way in which this indoor light alters the appearance of the form and changes the mood of a composition.

Directional light

1 ▶ Using a tinted flock pastel paper, map out the contours of the face in an earthy red. There is strong light coming in from the left, so start blocking in the shadows in a cool blue.

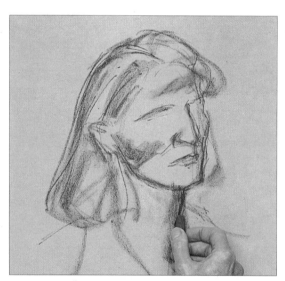

2 ◀ Look hard at the face and see which areas are thrown into shadow by the lighting and which are thrown into relief. Use a strong yellow to capture the highlights on the forehead, cheekbone, nose, and neck.

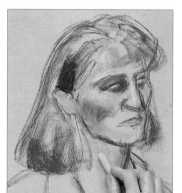

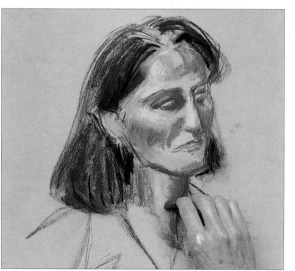

3 ◀ Start building up the tones, using light browns and reds for the warm lights in the hair, and purples and blacks for the shadow. The pastel clings to the textured surface of the paper, allowing for very little movement once the color has been applied.

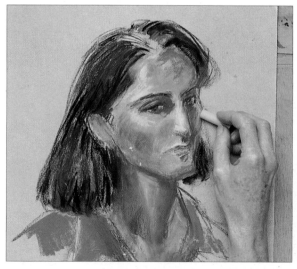

4 ▲ Continue adding the lights and darks, leaving the eyes for one of the final details so that the whites do not get muddied. Although one side of the face is in shadow, there is nevertheless a certain amount of light reflecting off that cheekbone.

Reversing the light

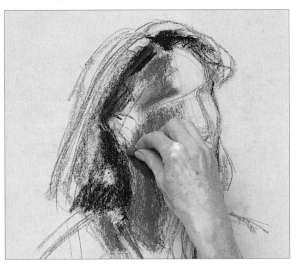

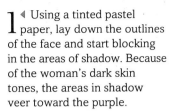

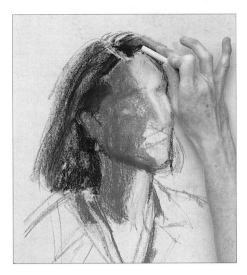

1 ◄ Using a tinted pastel paper, lay down the outlines of the face and start blocking in the areas of shadow. Because of the woman's dark skin tones, the areas in shadow veer toward the purple.

2 ▷ Apply golds and creams to the highlighted side of the face, emphasizing the form of the nose and the cheekbone. The light transforms the local color of the hair so that the black appears a reddish brown. Apply pale blue highlights to the top of the head and blend.

3 ◄ Draw in the eye and eyebrow with a dark brown and then use a greenish gray to define the contours of the nose and eye. Because of the quality of the flocked paper, you can lay down colors and blend them with your fingers to create areas of shadow.

4 ◄ To complement and heighten the warm colors of the head, lay down a cool background color. Apply strokes of turquoise around the side of the face and then blend the color outward with the side of your hand. This has the effect of softening the tone as the blue spreads outward, moving farther from the face.

Aspects of a woman

Light defines form as well as creating mood. Here the two images of the woman look quite different largely as a result of the way the light strikes her. In the image on the left, there is a sharpness to the contours on her face, with strong cheekbones and chiseled lips. Her blouse is a radiant blue, balancing and complementing the olive skin tones. The right-hand portrait appears softer, the tonal changes on the side of her face in shadow are more subdued and the blue of the blouse is almost bleached out by the light.

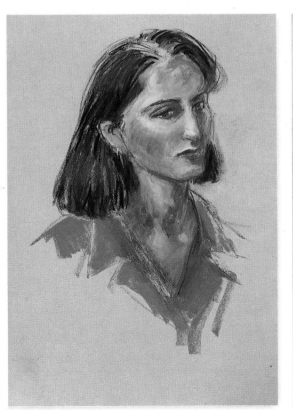

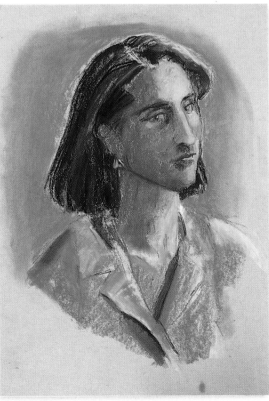

Sharon Finmark

Scumbling

THE TECHNIQUE OF SCUMBLING is a means of building up a pastel painting in layers. The side or blunted tip of a soft pastel is lightly drawn across the surface of the paper to create the effect of a delicate veil of color through which some of the underlying color is visible. Enough pressure is applied to impart grains of pastel to the raised tooth of the support without obscuring or lifting the previous layer of color. The characteristic quality of scumbling is a broken color effect where the newly laid color, interacts visually with the underlying color causing the colors to "sparkle." Because the technique involves applying layers of pastel, there is a tendency for the tooth of the paper to fill up. To counter this, fixative spray can be used to fix each successive layer of pastel and create a new surface for subsequent applications of color to adhere to.

Blue over pink

Pink over blue

Scumbled marks
Although the same two colors have been applied in the pairs above and below, the visual effect is quite different depending on which color has been scumbled first. See also how the randomness of the marks creates interesting textural and color effects.

Ultramarine over yellow

Yellow over ultramarine

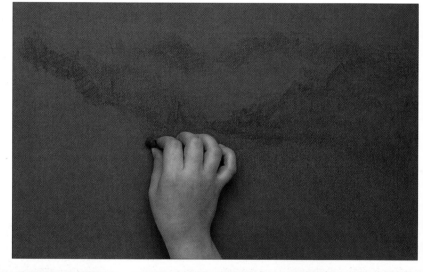

1 ▶ For this exercise the artist has studied a black and white photo of a landscape and used it as a springboard for her imagination. For a similar effect, use dark-toned paper and apply a bright blue in circular movements with the side of the pastel. The purple is then blocked in, defining the middle ground of the painting.

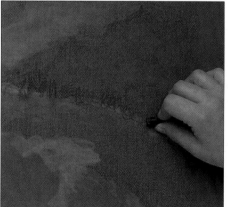

2 ▲ Taking a lighter blue, fill in a distant mountain and highlight some areas in the foreground. To start creating a point of interest, scumble in a line of fir trees along a diagonal ridge.

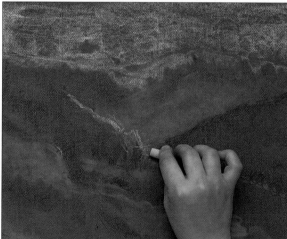

3 ▲ Take a cream-colored pastel and scumble the sky using the side of the pastel. Then use a broad line to define the point at which the mountains meet.

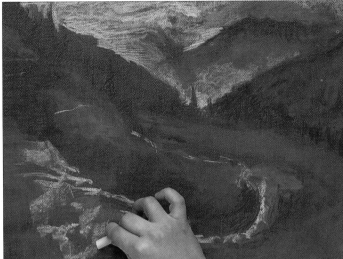

5 ◀ Following the principle that in a landscape warm colors appear to advance and cool colors appear to recede, use a warm yellow to define the area closest to the viewer. Notice how powerful the color is, drawing the eye immediately to the foreground.

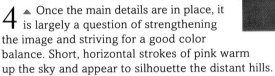

4 ▲ Once the main details are in place, it is largely a question of strengthening the image and striving for a good color balance. Short, horizontal strokes of pink warm up the sky and appear to silhouette the distant hills.

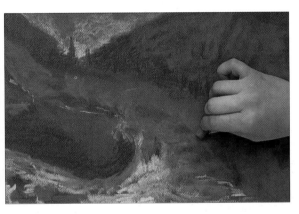

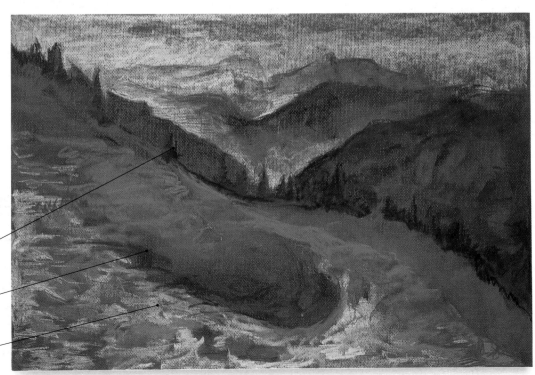

6 ◀ Always using the side of the pastel, overlay veils of gold, purple and a rich turquoise. The strength of the colors now vies with details such·as the trees, which will need building up.

7 ▲ The final application of yellow to the sky creates a sense of depth and balances the vibrance of the foreground. Approximately six different colors have been scumbled over the sky to arrive at this rich density of color.

Distant hills

The scumbling of veils of color has produced a compellingly rich surface to this image. Layers mingle to create surprising new hues, and the darkness of the ground reacts with the pastels to strengthen certain colors and tone down others. Diagonals lead the eye back and forth over the picture, and colors appear to recede into the background.

The darkness of the trees is arrived at by overlaying strokes of blues, greens, and purples rather than applying black.

Notice how the original color of the paper is still visible even with this degree of overlaying.

The strength of the gold visually vibrates against the contrasting tone of the purple paper.

Tamar Teiger

FEATHERING

Charcoal sketch

FEATHERING IS A TECHNIQUE of laying delicate parallel strokes of color with the point of a pastel, usually over an existing layer of pastel color. It is close to the technique of hatching in that the strokes serve to assert and clarify the planes of a form while creating a coherent surface of marks. And like the technique of scumbling, feathering is a means of enlivening a flat, even area of color and can be used to modify a tone in a pastel painting. When you add fine strokes over an existing color, the two colors appear to mix, which creates subtle color changes. This can be used to particularly good effect if, for example, you wish to capture the shimmering quality of light in certain atmospheric conditions.

ENLIVENING COLORS

The technique of feathering in which short strokes of one color are overlaid onto another can greatly enrich the feel of a work. In the first example below, the blended colors of the jacket and the chair produce a realistic image but one that is nevertheless somewhat flat. The shadows give it a certain sense of form, but not nearly as much as in the lower feathered example. Here the overlaid colors create a far greater richness, particularly in the folds of the jacket and the seat of the chair.

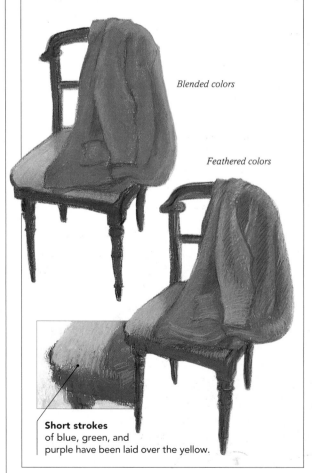

Blended colors

Feathered colors

Short strokes
of blue, green, and
purple have been laid over the yellow.

1 ◀ Block in the main areas of color, using the tip and the side of the pastels. You will need several shades of each color to capture areas of light and shadow. Here downward strokes with the side of the pastel create a sense of the folds in the fabric.

2 ▶ Start by feathering the fabric of the chaise longue. Overlay parallel strokes of ochres, reds and gold. Each additional color serves to modify the overall effect.

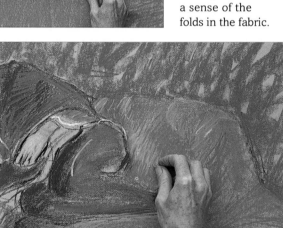

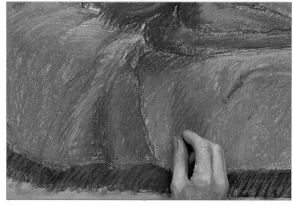

3 ◀ Complementary colors placed next to each other create a powerful effect. In this case the addition of green counterbalances the richness of the oranges in the folds of the fabric, just as the purple in the trousers works against the strokes of yellow.

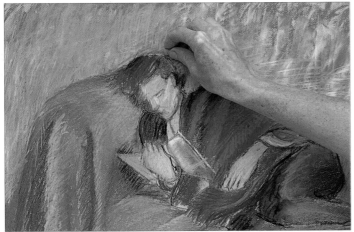

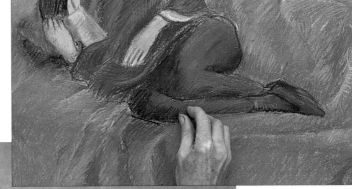

4 ◀ The original purple of the background has been scumbled on in loose, circular movements. To achieve a more muted effect, tone down the color with a paler hue such as lilac and start blending it in with your fingers. If the background still appears too dominant, blend the pastel with some cotton balls to lift a little of the color.

5 ▶ Following the principle of implementing complementary colors for creating shadows, overlay a cool green to counterbalance the warm pinks of the flesh tones in the areas of the hands and neck.

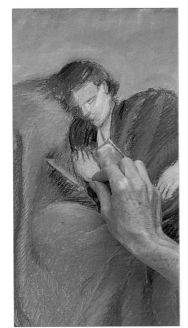

6 ▲ To counteract the flatness of the trousers, apply short strokes of blue, purple, and brown over the original color. These feathered strokes create a greater richness of hue in the areas of shadow.

7 ▲ By feathering pale blues and pinks over the darkness of the blue, you arrive at this very strong quality of light, which accentuates the sense of form.

Woman reclining
The finished picture is bathed in a glowing light that has been achieved by feathering strokes of high-key colors into the rich local colors of the figure and drape. There is a pleasing balance between the relaxed pose of the figure and the gentle curves of the chaise longue.

See how shades of green have been feathered into the orange of the drape to create the sense of folds and shadows.

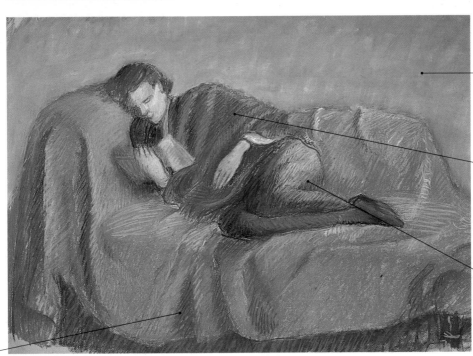

The flatness of the background is achieved by blending the colors.

The rhythmical curve of the shoulder is echoed in the shape of the chaise longue.

Short strokes of blues, oranges, browns, and lilacs add to the sense of form in the legs.

DRY WASH

THE TECHNIQUE OF DRY WASH is a method of laying a broad area of color in a uniform, unbroken tone. It is a way of achieving seamless transitions of two or more colors and so is particularly suited to creating subtle atmospheric effects in landscape painting. To prepare a dry wash, simply scrape or crush a pastel into a fine powder. You can then either tip the powder directly onto areas of the support to create dense areas of color or pick up the powder using a brush, rag, fine sponge, or cotton ball and then work the powder into the support. Whichever method you choose, you can then blend the powder into the support with your fingers or any of the other blending tools, depending on the effect you desire (blending with your fingers creates the strongest tone). You can achieve subtle and precise blending of dry washes by either mixing different powdered pastels together before you apply them or overlaying individual colors directly on the support.

1 ◀ With a scalpel, scrape the end of a dark olive green pastel onto your paper. Try not to apply too much pressure as you do this – you could find yourself with chips of color rather than fine pastel powder, or even break the pastel completely.

2 ▶ Now work the powder into the paper with your fingers. You will be surprised at how far a small amount goes.

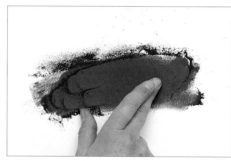

3 ▲ Another way of laying a dry wash is to scrape pastel powder into a dish and apply it with a cotton ball. The effect will be less dense than when you use your fingers, since the cotton ball fibers retain some of the pigment.

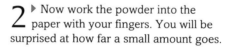

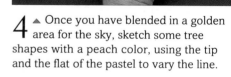

4 ▲ Once you have blended in a golden area for the sky, sketch some tree shapes with a peach color, using the tip and the flat of the pastel to vary the line.

5 ◀ Complete the trees using a combination of dry wash techniques for the foliage and conventional drawing techniques for the trunks and outlying branches. Now sprinkle pastel powder onto the sky to create cloud shapes and blend them in with your fingers.

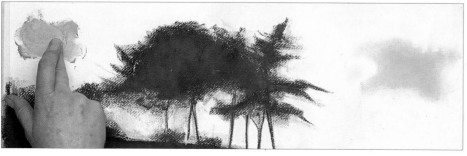

RECONSTITUTING PASTELS

Inevitably, pastels will break as you work and you will find yourself with dozens of fragments, too small to use. Don't throw them away. Save them, sorting them into groups of similar colors, and use them to make new pastels later. The process is extremely simple and you can create your own rich colors from your various bits and pieces. You can use skim milk to bind particularly soft pastels and give them a slightly harder texture. Most pastels, however, contain enough binder to be reconstituted by simply adding water to the powder and mixing it.

Pastel fragments

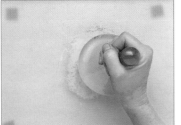

1 *Take your yellow pastel fragments and grind them into a fine powder with a muller on a glass slab.*

2 *Grind the blue pastel fragments in the same way. Once they are finely ground, you can start to mix the colors.*

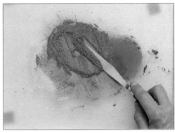

3 *Use a palette knife to mix the colors into each other. After a period of time, the blue and yellow will form a green.*

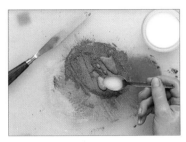

4 *Add a spoonful or two of skim milk, mixing it in with the knife until you arrive at a fairly dry paste.*

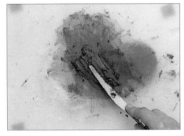

5 *Fashion the paste into a roughly oblong mass, first with the palette knife and then with your fingers.*

6 *Place the pastel on absorbent paper and roll it with your fingers. Leave it to dry at room temperature for 24 hours.*

Chunky new green pastel

6 ◀ Finally, to enliven the foreground color and create a greater sense of depth, sprinkle some bright blue pastel powder onto certain areas of the green and blend it in with your fingers. The combination of magenta and this bright blue blended into the green creates a richly varied surface.

The dry wash technique is ideal for creating the subtle, hazy feel of the sky.

Materials

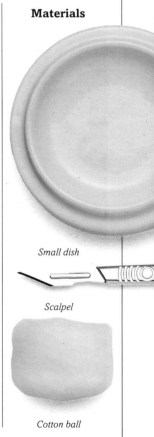

Small dish

Scalpel

Cotton ball

Hampstead Heath
The dense tones achieved by the dry wash technique have been used to create an image of both striking tonal contrast and subtle color modulation. The artist has balanced the positive shapes of the hillside with the negative shape of the sky.

The broken silhouette of the branches, scumbled with the side of a pastel, relies for its effect on the tooth of the paper showing through.

If you look closely you can see distinct layers of blue, magenta and green in this area.

See how the dry wash has filled in the tooth of the paper.

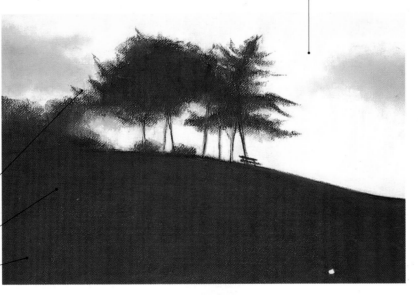

Felicity Edholm

EXPLORING TEXTURE

THE ADAPTABILITY OF soft pastel to both drawing and painting techniques makes it an ideal medium for exploring textural qualities. The pastelist can apply a striking variety of marks ranging from delicate traces of line to full impasto (rich, thick applications of paint), and from loose, open scumbling to smooth, blended transitions of tone. As can be seen below, the versatility of pastel provides an exciting opportunity to exploit a diversity of textures. Here the artist has chosen an imaginative combination of textural materials that evoke a surreal and dreamlike association with the sea. The luminous arrangement of disparate forms appear to float as jetsam and contrast with the dark folding waves of deep green velvet.

Dried flowers

TRANSPARENCY

Painting glass presents particular sets of problems since it is both a transparent material and a reflective one. Light plays on its surface and also through it, altering the tones of what lies within. Here, as light passes through the glass there are subtle changes of tone from a warm orange-red to a cooler magenta, as well as highlights where the glass reflects the light source.

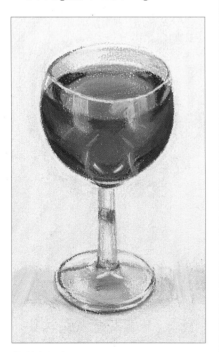

Painting glass
To capture the essence of liquid within glass, start with a pencil drawing. Study the different tones of the wine and apply first the mid-tones, blending them in a circular motion with your finger. Build up the darker tones and then add white to the rim and sides of the glass for highlights. Overhead light passing through the glass casts a pink-violet tone.

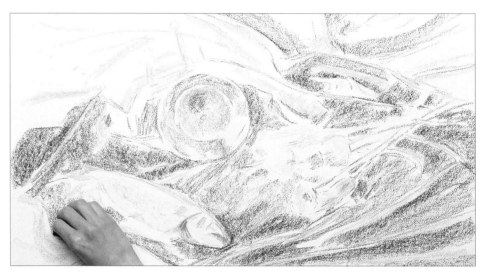

1 ▲ Here a trumpet, dried flowers, and a fish are laid on velvet to create an interesting range of textures. As the composition is quite complex, start with a pencil sketch and then block in the main areas of color using the side of the pastels. It is a good idea to start with mid-tones and then gradually build up the lights and darks.

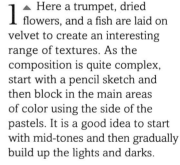

2 ▲ For the velvet, apply broad swathes of green with the side of the pastel and then overlay similar swathes of a dark blue. The velvet is soft, so you should draw the side of the pastels across the paper in fairly soft, broad sweeps. Blend the blue into the green with your fingers, following the lines in which the color has been applied.

3 ▶ The flowers with their spiky shoots and leaves demand quite different treatment. Draw in some of the stems in bold, continuous movements using the tip of the pastels, pressing down quite hard, and use short spiky lines to outline the flower heads. Next, return to the deep turquoise to outline some of the shapes and define their forms against the velvet.

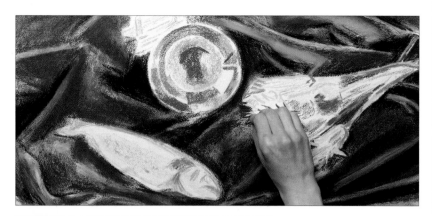

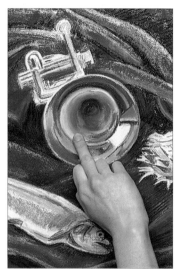

4 ◀ For the reflection of the velvet on the trumpet, apply a range of blues, greens, and yellows, following the line of the bell. The shiny effect is achieved by blending each color in turn with a finger. Be sure to clean your hands between colors to avoid smearing one color over another.

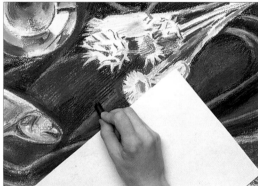

5 ◀ Continue building up lights and darks, adjusting areas as you work. If you are worried about disturbing areas you have already painted, lay a sheet of paper on the image and rest your hand lightly on your work.

6 ◀ For the shiny, somewhat wet surface of the fish, draw lines of different colors along its body – blues, grays, pinks, and muted yellows – taking care not to fill the tooth of the paper. By not pressing down too hard with the pastels you can take advantage of the texture of the paper to create the impression of the fish's scales.

A musical composition
The artist has chosen a large sheet of watercolor paper – 22 x 30in (56cm x 76cm) – in order to be able to work in considerable detail. She finds that the pastels are simply too large to execute finely detailed work on smaller-sized sheets.

The bell of the trumpet forms the focus of the composition, acting as the still point of a vortex of lines of movement.

The lustrous skin of the fish has been achieved through a mixture of scumbling and blending techniques. The delicate blues and gray-greens have been scumbled, while the pink and white highlights have been blended with a finger.

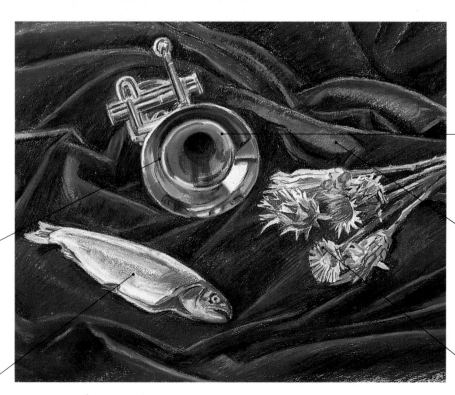

The smooth form of the trumpet has been modeled by means of a careful blending of the warm tones of the brass reflecting the cool tones of the light and the surrounding velvet cloth.

The cool deep turquoise of the velvet has been highlighted with warmer notes of green along the folds.

The dry strokes of pastel used to define the spiky forms of the dried flowers contrast with the blending technique used to achieve the wet and shiny forms of the fish and trumpet.

Jane Gifford

GALLERY OF TECHNIQUES

THE MOST IMPORTANT FEATURE to appreciate about pastels is that they are open to a diversity of drawing and painting techniques. Each of the pastel works in this gallery shows how the artists have selected a particular technique that is appropriate to the interpretation of their subject matter. For the majority of artists, the development of their particular solution has been arrived at through experimentation, which has evolved through trusting their creative instincts and enjoying the many possibilities of this exciting and promising medium.

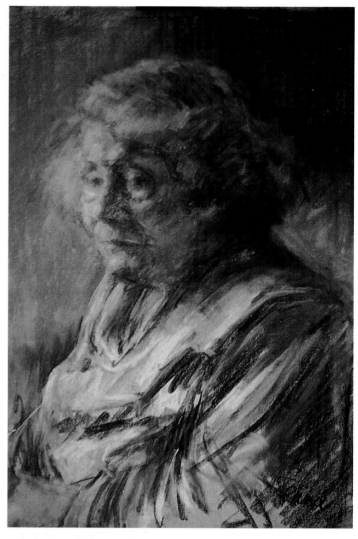

Ken Paine, *Mrs. Groffes* 25 x 21 in (64 x 54 cm)
In this moving portrait, Paine has used a limited palette of colors and a range of techniques to invest the composition with emotional presence. He has concentrated on the face, modeling the woman's features delicately to create this dreamy, soft-focus effect. He has treated the woman's dress quite differently – with vigorous open hatching and long, bold strokes – so as to balance the composition and not distract from the essential quality of the portrait.

Sally Strand, *Eggs under Water*
36¹/₄ x 48¹/₂ in (96 x 123 cm)
Sally Strand's work is characterized by an exceptional sensitivity to the blending properties of soft pastel. Here she demonstrates the use of blending and feathering as techniques of modeling form and as a means of controlling the delicate transitions between light and shadow.

In this detail, you can see the subtle blending of warm and cool hues that establish the light reflected by the eggs and refracted by the surrounding water.

Sophie Aghajanian, *Mirror Image* *22 x 30 in (56 x 77 cm)*
Sophie Aghajanian works on Fabriano paper in a technique called sfumato (smoky), and achieves a dreamlike quality in her painting by means of a dry wash. For this, she scrapes pastels into a fine dust, which she then works into the support using her hands, a cloth or tortillons. This composition is a striking example of how a simple subject can be transformed by the way in which it is arranged. The dramatic tilt of the mirror is counterbalanced by the downward movement of the flamelike flower heads.

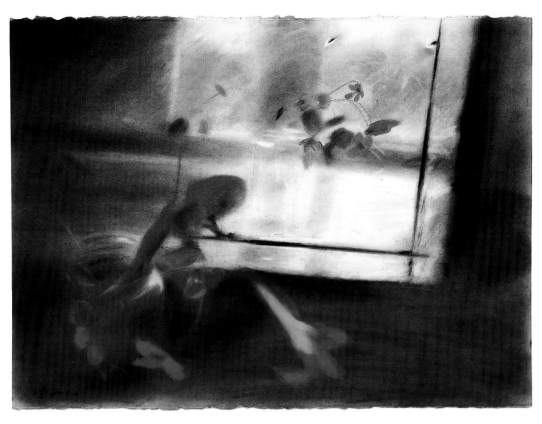

The forms of the jam jar and the flowers emerge out of darkness and are invested with unexpected associations of flight. The intensity of the petals comes from the purity of the pigment powder.

Ken Draper, RA, *Nile, Last Light,* 1993 *18 x 20 in (46 x 51 cm)*
Much of Draper's work develops from a highly imaginative interpretation of landscape using a technique which frequently combines the dry quality of soft pastel with the dense impasto of oil pastel. Here he has blended areas of dusky blue-violet over darker tones, building up areas of pastel and scratching back to achieve a great richness of texture. In this evocative composition, the pale evening sky is suspended between the silhouetted landscape and the majestic canopy of dense black clouds.

This detail shows Draper's mastery of techniques as he creates vibrant, pulsating areas of red against the subtly blended darker tones.

Here Draper creates ripples on the painting surface by dragging dark, rich tones of oil pastel over hazy, blended areas of soft pastel.

USING OIL PASTEL

OIL PASTEL HAS DISTINCT qualities that require a different approach than the other pastel types. It is suitable for bold, colorful composition as it adheres vigorously to the support, rapidly filling the tooth of the paper, but at the same time it can be dissolved by turpentine and used more like a wash. Its range of hues is more limited than with soft pastels but this is compensated for by the way transparent colors can be overlaid on the support. The performance of oil pastels is altered by temperature; they become softer and more fluid as they warm up. Because of this, it is best to keep them in their original wrappers to prevent them from sticking to your fingers.

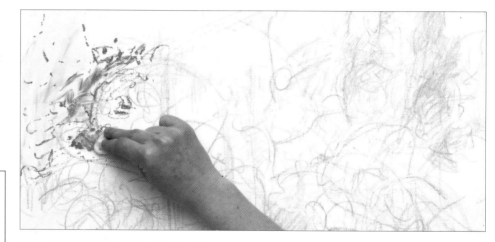

Basket of silk flowers

1 ▶ Using oil paper, sketch in a rough composition with some yellows, blues, and greens. When you are happy with the basic arrangement of forms, start building up the color. With a cotton swab, wet an area of the paper with turpentine, draw in some blue lines and blend the blue with the wet cotton swab. Note how some of the color soaks into the paper.

RANGE OF EFFECTS

This simple sketch of the artist's daughter shows the variety of effects you can achieve with oil pastel, from lines of varying thicknesses to subtle washes of color to dense areas of pigment. Here, the tip of the pastel has been used to draw in the outlines and to suggest areas of shadow. The smooth tones of the background are the result of laying down light strokes of turquoise and then blending them with a cotton ball. The flower in the girl's hair is suggested by a thicker, impasto application of colors.

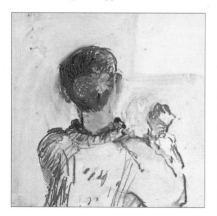

Hayley sketching

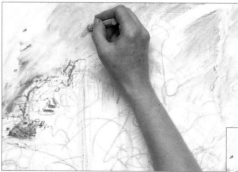

2 ◀ For the background, apply strokes of turquoise using the tip of the pastel and then blend the area with a dry cotton swab. Blending on dry paper without the addition of turpentine creates a much more even effect than on the wet paper, as the oily color stays on the surface.

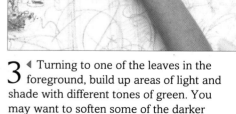

3 ◀ Turning to one of the leaves in the foreground, build up areas of light and shade with different tones of green. You may want to soften some of the darker green by blending strokes of pink into it.

Materials

Cotton ball

Turpentine

Penknife

4 ◀ Pressing quite hard with your pastel, lay a thick application of green and then scratch lines out of it with a blade. You can use this "sgraffito" method to draw veins into leaves or simply to get back to the paper if you wish.

5 ◀ For the aster with its rich cluster of petals, stipple the red onto the paper. Stippling involves laying a pattern of dots on the surface of the paper to create an impression of form. Viewed from a distance, the colors will appear to mix, in an effect known as optical mixing.

6 ▶ Cotton balls, either wet or dry, can be used to blend colors or model forms. Here a cotton ball lifts off some of the pink from the petal, creating a sense of light falling on it and giving it a greater three-dimensionality.

A riot of flowers
This composition demonstrates a diversity of oil pastel techniques and, in particular, the use of turpentine to dissolve oil pastel into transparent washes. By blending, stippling and scratching out, the artist has echoed the huge variety of shapes and textures visible in the many different flowers.

Note how the color of the strut in the wicker basket has been arrived at by overlaying a range of blues, pinks, purples, greens, and browns.

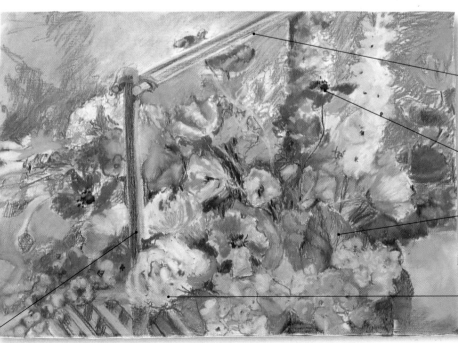

The artist has used the diagonal angle of the handle to contrast with the curvilinear forms of the flowers.

The anemone, with its stippled corona, draws the eye up toward the taller hollyhocks at the back.

The leaf forms a point of interest in the foreground area.

The impasto effect, with its blobs of white color, is clearly visible in the petals of the chrysanthemums.

Rosemary Saul

SOFT PASTEL AND WATER

THE USE OF WATER with conventional soft pastel techniques creates surprising and dramatic results. You will need to have a fairly heavy watercolour paper taped to a board to stop the paper from buckling or tearing. Block in areas of colour and then either spray water on to the pastel or work into the colour with a wet paintbrush. As the pastel particles absorb water they will temporarily darken in tone.

The absorbency of pastel can be used in another technique, which involves wetting the paper support with a brush, sponge or spray before working pastel on the surface of the paper. As the pastel touches the paper it is transformed into a thick, rich impasto. Alternatively, you can grind pastel to a powder state, add water, and then apply the paste in varying degrees of dilution as a wash.

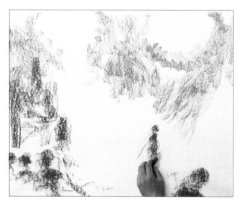

1 ▲ Using the side of the pastel, block in areas of purple and red for the night sky and brown for the foreground figures. The drawing can be quite sketchy at this stage, since the addition of water allows you to make alterations later.

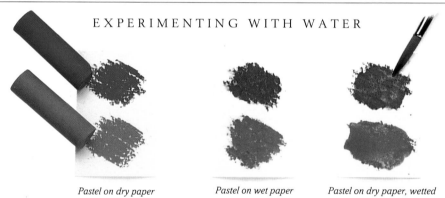

EXPERIMENTING WITH WATER

Pastel on dry paper *Pastel on wet paper* *Pastel on dry paper, wetted*

These swatches show the same soft pastel colours used in three ways. The first shows pastel applied in a normal way on to dry paper. The second shows marks made on to wet paper in which the pastel colours have absorbed some of the water and so seem thicker, more like gouache paint. And in the third the marks have been made on to dry paper and then wetted with a brush so that the pigment particles have dispersed on the support.

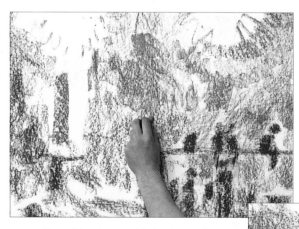

2 ▲ Scumble some red in loose strokes over the purple and then "paint" over the area with a large round paintbrush dipped in clean water. The red pigment particles will immediately be dissolved by the water and will wash over the page like a very strong watercolour paint.

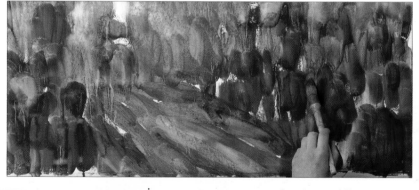

3 ▲ Continue adding colour and washing over the composition with a wet brush in broad, loose strokes. Remember to dip your brush in clean water as you work on different areas, so as to preserve the vibrance of the individual colours.

4 ◀ To create a cascading firework, spray water on to the paper and apply short strokes of a bright blue on to the damp surface. The blue adheres to the paper in a rich, impasto effect. Now draw some of the blue down the painting with a sponge.

5 ▶ You can wash out an overworked area and start again. Here the artist wetted the sky and lifted off most of the paint with a paper towel. He then reworked the firework on the left and added the sparkler.

Materials

Large bristle wash brush

6 ▲ Apply more strokes of browns, pinks, and yellows, and paint over them with a wet brush. The colours will dry lighter than they appear while they are wet as the water evaporates from the pigment.

7 ▲ Once you are satisfied that the main elements of the composition are in place you should highlight any details that you want to emphasize. The addition of a bold yellow in the foreground creates an eerie sense of light in this bright night sky.

Synthetic brush

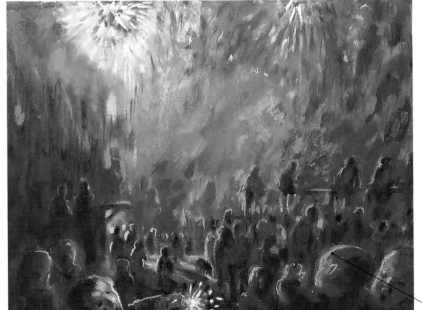

Firework display
The artist has tried to capture the ambiguous feelings induced by a firework display. The fascination with the dramatic light effects of the exploding fireworks is tempered by associated thoughts of war and man's ingenious destructiveness.

Natural sponge

The forms of the standing figures are loosely defined by silhouetting them against the light from the exploding fireworks.

Water spray

Michael Wright

PASTEL AND CHARCOAL

CHARCOAL IS OFTEN USED as a starting point for a pastel painting and is valuable both for creating the structure of a work and for establishing a tonal balance. It is easily manipulated across the surface of the paper and can be altered without difficulty by using bread, a kneaded eraser or the heel of the hand. Although you can alter or obscure charcoal lines quite easily, it is not always desirable to do so, since the charcoal adds a depth of tone

Working sketch

and acts as a visual scaffolding for the layers of color. You can also use it in the final stages of your composition for accentuating lines or strengthening certain areas. When you work with charcoal, you may need to fix it so that it does not blend into any subsequent layers of pastel.

TYPES OF CHARCOAL

Willow charcoal

Compressed charcoal

Willow charcoal comes, as it sounds, from the willow tree and is essentially just twigs, dried and fired, to be used as a drawing medium. It is particularly good at the initial drawing stage, since it is easily manipulated and altered. Compressed charcoal is made from Lamp Black pigment mixed with a binder and compressed into round or square sticks. It produces a denser, richer line than the willow charcoal and is harder to alter once on the paper.

1 ◀ Use a piece of charcoal to sketch in the basic shapes. Here the artist has opted for compressed charcoal, which produces a deep, rich velvety black line. This is less easily displaced than willow charcoal.

Preliminary sketches
Spend some time studying the elephants, watching how they carry themselves, how they move, how they interact with one another.

2 ◀ Continue building up the elephants, blending areas as you go along. Draw in some verticals and horizontals to place them within the composition.

3 ◀ Block some aqua into the background to create a sense of depth. The crimson highlights on the elephants' heads add a startling touch, drawing you into the picture to look more closely at their faces.

4 ▶ Using the flat of a pastel, start filling in some background details. Block in the red door at the right and lay in a corner of yellow. See how these few colors begin to give your painting some weight and solidity. It is now largely a question of adjusting the color balance in the composition.

5 ▶ Add colors in loose, broad strokes, scumbling blues and purples into the background. Zigzag a sharp turquoise line to build up the color on the right of the composition. Add areas of white to the bodies of the elephants and blend them in with your thumb. These highlights are in sharp contrast to the black of the charcoal and form a powerful counterpoint to the image.

6 ▶ Returning to your charcoal, go over the violet of the railing to give it a greater sense of form, and draw in a gate on the left. Add layers of blue, purple and scarlet to the upright post to create an interesting texture. If you are not happy with the way the charcoal and the pastel mingle, spray the various layers with fixative.

7 ▲ Take your charcoal and redefine areas of shadow on the elephants, drawing in lines and then blending them. Charcoal can be used to add a depth of tone to your work, particularly in the darker passages of your composition.

8 ◀ Continue building up the colors, working over the image as a whole. Here the belly of the elephant nearest to us is made up of a range of grays, a crimson, and a green. The various colors are applied in short, diagonal strokes and appear to mix optically.

Elephant house

The combination of charcoal and pastel has been used to dramatic effect in the play of light and shadows throughout this composition. The rhythmical, muscular forms of the elephants are contained by the severe geometry of their environment. As light falls into the enclosure, it creates cool tones and reflections on the wet concrete and serves to heighten the sense of confinement of the elephants.

The use of red here counterbalances the red of the door on the right-hand side.

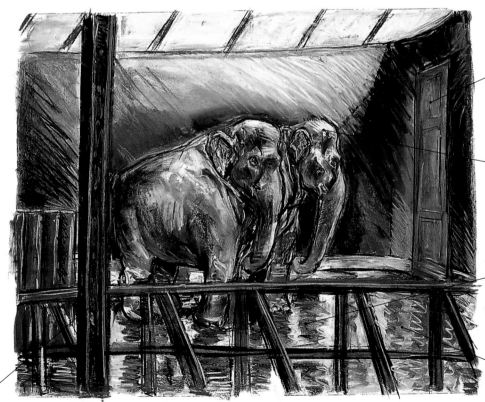

The artist has used the red door set against strident black lines to amplify the theme of confinement.

The play of light across the elephant's head sharply defines the extraordinary structure of the beast's skull.

The barren environment has been given a vigorous treatment in the assertion of a contrasting rhythm of light and shadow across the floor and railings.

This corner of the composition shows how every surface is linked by a recurring theme of cool purple and blue shadows.

Ian McCaughrean

GALLERY OF MIXED MEDIA

ALL THE FORMS of pastel can be worked together or with other media. The most common technique is to lay down an acrylic, watercolor, gouache, or ink wash as a base for overworking in soft or hard pastel. Another option with startling effects is to use a "resist" technique in which an oil pastel drawing is overlaid by a water-based wash. The oil pastel resists the overpainting, emerging free of the wash.

Lucinda Cobley, *Palace on the Lake* 7 x 5 in (18.5 x 12 cm)
In this small but powerful composition, the artist has worked soft and oil pastel over an acrylic base. She has greatly simplified the architectural form so that the work relies for its impact on the striking and evocative contrast of warm and cool colors, and the unusual way the wet and dry media interact with the texture of the paper.

In this detail, a lilac soft pastel has been lightly scumbled over the orange to create a broken effect on the texture of the watercolor paper.

Here, an intense red has been encouraged to bleed into the surrounding lighter orange wash.

The strong lines of Conté crayon create the skeleton of the composition, defining the forms and leading the eye on a journey across the picture plane.

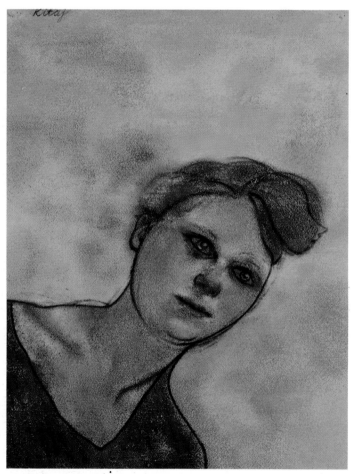

R.B.Kitaj, RA, *Red Eyes,* **1980** *30 x 23 in (76 x 60 cm)*
Kitaj is a superlative draftsman and has used charcoal here as an integral part of the pastel work rather than as an underdrawing. The strident line that defines the contour of the form and accentuates the visual details contrasts with the subtle modulation of the coloring. This surprising and moving diagonal composition displays Kitaj's consummate skill in portraying the human condition through drawing.

Frances Treanor, *Nude Study* *11¹/₂ x 8¹/₄ in (31 x 21 cm)*
In this dynamic nude study, the artist has used a combination of oil pastel and felt-tip pen with great confidence, as both media require a surety of drawing and allow little scope for alteration. The work has been executed in a vigorous treatment of broad strokes of oil pastel that overlay and complement the tightly controlled black felt-pen line, which defines the contour of the form. The surrounding negative shapes of blue and violet add to the dramatic impact of the angular arrangement.

The broken areas of red pastel create a striking pattern of white shapes that jump against the dense violet-black mass of the model's hair while forming an anchor to the diagonal movements of the image.

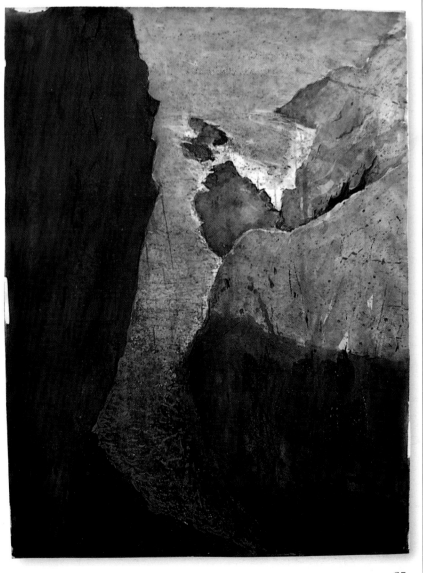

Unlike the oil pastel, the black felt-tip produces a line of consistent strength and thickness, lending a clarity to the contours of the woman's face.

Paul Lewin,
Kenidjack Castle *22 x 17 in (55 x 43 cm)*
Lewin is a contemporary landscape artist who has produced a series of works exploring compositional arrangements between the natural elements of sea and rocks. In this startling image, he induces a sense of vertigo as the rock face drops steeply into the shadowy chasm. The image has been worked through an inventive treatment of scraped, blended, and scumbled soft pastel over washes and spatterings of watercolor. The artist works his compositions on site, usually finishing a work in one day of intense activity, spraying the pastel work with fixative between layers.

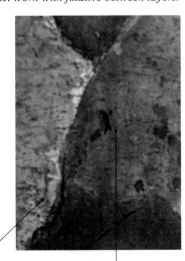

The texture of the sea has been created through an inventive play of watercolor overlaid by rhythms of dense pastel work, the direction of the strokes suggesting the movement of the water. The impression of sunlight striking the water at the point where the rocks meet has been effected by laying a wash of pale blue watercolor.

The layers of color in the rock face reveal the interplay of washes of watercolor overlaid by bold strokes of soft pastel.

THINKING BIG

SOME PEOPLE THINK of pastel as a delicate, genteel medium, but it is as suited to robust, ambitious compositions as any other painting media. Indeed, in some ways it is especially suitable since the pastels are a dry painting medium and so large sheets of paper will not buckle or warp as you work on them. If you want to experiment with sizes and formats, you have a number of options: you can either work on several standard sheets of paper and then join them,

use rolls of artists' quality watercolor paper or drawing paper cut to a specific size, or work on large sheets of canvas as a support. If you are working on individual sheets of paper you can add to them and build up a virtual tapestry of images.

Initial photos for reference

THE ARTIST HAS developed two radically different compositions exploring alternative means of building large-scale works in pastel. One is a multiple image brought

together in the form of a "joiner," and one is a mixed-media composition that exploits the richly varied properties of pastel and collage.

Since working on this scale is impractical to attempt on site, the solution is to take photographs or make sketches which explore the compositional possibilities

of your subject. If you work out a composition on a small scale, you can then translate this to a larger format. You can either draw a grid of squares onto your original or onto a sheet of acetate that you place over your original. You then draw an identical grid onto your large support, making sure the proportions match, and copy your image square by square.

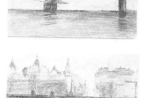
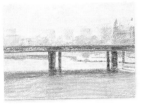
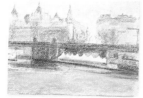

Split images
Working from a series of photos of the scene, the artist settled on four separate panels to capture the expanse of the bridge and London's river panorama. Here, the panels appear more as a related group of images than as a single composition.

Panoramic view
Here, the panels create an extended composition punctuated by the rhythmical vertical notes of the bridge supports. The bridge spans the river and links the separate panels in a warm thread that runs through the heart of the scene. Its impact is complemented by the delicate panorama of buildings in the background.

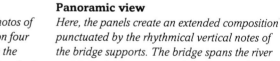

Varanasi bull

In this striking composition, which is roughly 5 ft by 4 ft (155 by 125 cm), the artist has engaged in a tour de force of imaginative interpretation. The large scale of the composition has encouraged her to exploit the use of collage as a means of laying extensive, flat areas of color. By including a range of colored and marbled papers, she has lifted the image into an imaginative realm rather than creating a facsimile of the original experience. She has used delicate lines of pastel to denote the door lintel and pick out the architectural details, and a much denser application of pastel within the shrine to lead the eye into the distance. The image has been worked on a length of paper cut from a roll of artists' quality watercolor paper and stapled to a sheet of soft board.

Hand-textured and colored sheets have been torn and cut to create contrasting edges that evoke the stonework of the building.

By scumbling color onto the collage of the bull the artist has created a leathery feel to the hide.

There is an inventive play between line and tone to describe the shapes of the hooves as they are framed against the strident red shadow.

PRESERVING AND FRAMING

GIVEN THE POWDERY NATURE of pastels, the surface of works executed in pastel is easily disturbed and needs to be protected from the effects of handling. The simplest method of caring for your work is to tape a sheet of glassine, wax paper, or tracing paper onto it so that it covers the image. These preserving sheets are nonabsorbent and so will not pick up or displace any of the pastel dust. Once you have covered your paintings in this way you can then safely store them on top of each other, either in a portfolio, in a map chest, or placed between two sheets of hardboard. If you decide to store them between sheets of hardboard, you need to tie the sheets together to prevent any lateral movement. Alternatively, you can attach your pastel work to a backing board, cover it with a suitable mat, and then frame it under glass. You need to use the mat in order to keep the surface of your work away from the glass. Apart from its attractiveness, framing has the additional advantage of protecting your work from the harmful effects of air pollution.

Materials

Glue

Brush

Rice paper

Masking tape

Museum board

Tracing paper

Mounting pastel works

It is a good idea to mount your pastel work, whether or not you plan to frame it, since the stiffness of the mounting board holds the paper firmly and protects against shedding of pastel pigment. It is best to buy acid-free backing board, also known as museum board. Measure your work and draw faint pencil lines to indicate where the corners of your picture will sit within the board you have chosen.

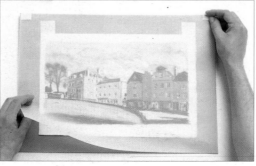

1 ◀ Lay the pastel work face down on a sheet of tracing paper. Cut lengths of rice paper, 2 by 1 in (5 by 2.5 cm). Fold the lengths in half and apply paste lightly to half of each hinge.

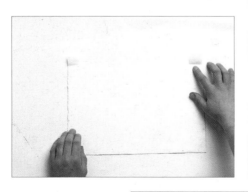

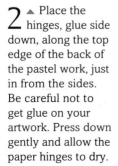

2 ▲ Place the hinges, glue side down, along the top edge of the back of the pastel work, just in from the sides. Be careful not to get glue on your artwork. Press down gently and allow the paper hinges to dry.

3 ▲ Put a little glue onto the remaining surface of the hinges, turn the pastel work over and place it centrally on the mounting board, pressing down lightly on the hinges to secure them.

4 ◀ If you are not intending to frame the work, you should attach a sheet of preserving paper to the back of the mat with masking tape so that it covers your painting.

Framing pastel work

It is advisable to frame your work if you want to protect it permanently. Choosing the right frame and mat is largely a matter of taste, but you should consider the effect each will have on the appearance of your work. As a general rule, choose a frame that is at least 2 to 3in (5 to 7.5cm) wider than your work and reflects the color key of the composition.

There is a wide selection of ready-made frames and mats available.

1 ▲ Measure the inside dimensions of your frame and mark these on the mat. Cut the mat to fit, using a sharp craft knife and steel ruler.

2 ▲ Using a mat cutter, cut a window to fit your work and tape the mat to your board.

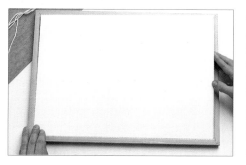

3 ◀ Making sure that the glass is free of any dust or smear marks, place your mounted work into the frame. Now place a backing board over it, cut to fit snugly against the edges of the frame.

4 ▲ Secure the board by placing a few brads at 4in (10cm) lengths along the inner edge of the back of the frame.

5 ▲ Place lengths of masking tape along the back of the frame to seal the join. This stops moisture, dust, and insects from gaining access to the picture surface.

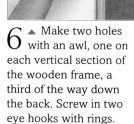

6 ▲ Make two holes with an awl, one on each vertical section of the wooden frame, a third of the way down the back. Screw in two eye hooks with rings.

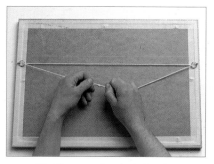

7 ▲ Finally, attach a length of picture-hanging cord to the rings. Your work is now ready to be hung.

Finished work

It is worth comparing this painting with the original version on page 35 to see the dramatic effects of mounting and framing.

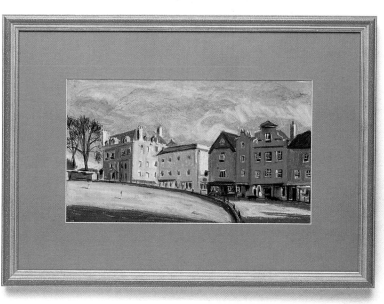

Materials

Mat cutter

Steel ruler

Hammer

Awl

Brads

Eye hook with ring

String

Mat board

Window mat

Glass

Frame

GLOSSARY

ACID-FREE PAPER Paper with a neutral pH made from rag, which will not yellow with age (unlike acidic bleached wood pulp).

ART BOARD Artists' quality paper mounted on posterboard. Its stiffness reduces the incidence of accidental pastel loss.

ARTISTS' QUALITY PAPER Paper with a high rag content, which, unlike wood pulp paper, does not yellow or become brittle with age.

BINDER A starch-based glue such as skim milk or tragacanth, used in dilution to bind water-based pastels and hold the pigment in stick form. Oil is used as the binder in the case of oil pastels.

BLENDING Mixing colors together on the pastel support by means of rubbing the pigment of one pastel into an adjacent or underlying color using a finger or stump.

BLOCKING IN Laying in a broad area of color using the side of a pastel.

BLOOM This refers to the characteristic powdery brilliance of the surface of an application of soft pastel.

BROKEN COLOR A light application of color that allows the underlying color to show through in an irregular pattern.

CARBORUNDUM PASTEL BOARD Board coated in a fine dusting of powdered carborundum. This creates an exceptional degree of tooth that can hold a thick application of pastel.

CHALK (PRECIPITATED) A very fine grade of chalk used in the manufacture of pastels to create paler colors, called tints, of the original pigment.

CHARCOAL Carbonized wood made by charring willow, vine, or other twigs in airtight containers.

COLOR WHEEL The primary, secondary, and tertiary colors arranged in a circle as colors are refracted in a rainbow: red, red/orange, orange, orange/yellow, yellow, yellow/green, green, green/blue, blue, blue/violet, violet, violet/red.

COMPLEMENTARY COLORS Those colors of maximum contrast opposite each other on the color wheel. For example, the complementary of a primary color is the mixture of the other two primaries, i.e. green, is the complementary of red because it is made up of yellow and blue.

CONTÉ CRAYON Chalk-based pastels with a square cross-section that are midway between soft and hard pastels in texture. Sold in a range of up to 80 colors.

COOL COLOR The colors between blue/purple and yellow/green are the cool hues on the color wheel. However, every hue has a cool version, i.e., one that contains a degree of blue.

CROSS-HATCH To overlay parallel strokes of color at roughly right angles to another set of parallel strokes.

DRY WASH The technique of working pastel powder into the support to create even areas of color. Soft pastels are pared with a knife or crushed to create a powder.

FEATHERING Laying roughly parallel strokes of pastel, usually over a previous area of color, to modify the original strength or tone. Also used to create atmosphere.

FIXATIVE A resin dissolved in solvent which is sprayed onto a pastel work to fix the pastel particles to the support. Fixative is also used between layers of color to prevent the previous layer of pastel from blending with the next one. Fixative should be used sparingly, as a heavy application will cause the colors to darken and lose the characteristic powdery appearance known as the bloom. Note: avoid inhaling fixative as it is hazardous to health.

FLOCKED PAPER A pastel paper or board that is sprayed with a fine coating of cloth fibers and grips the pastel pigment.

GLASSINE A paper with a smooth, shiny surface, used to protect a pastel work from smudging or accidental loss of pastel dust.

GOUACHE An opaque watercolor that is similar to soft pastels. Pastels can be reduced to gouache by dissolving the pastels in water and applying the pigment with a brush.

GUM SOLUTION A dilution of gum in water used as a binder to hold the pastel pigment in stick form. The greater the gum content, the harder the pastel.

HARD PASTEL A pastel with a high gum content, which produces a hard texture, suitable to preliminary drawing and detailed work. Hard pastels can be sharpened to a fine point and come in up to 80 colors.

HATCHING A technique of applying color in roughly parallel strokes; also a means of applying areas of tone.

HUE Description of a color in terms of its position in the color wheel, i.e. red/orange.

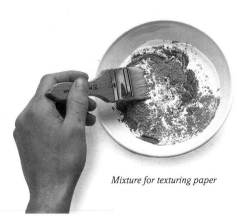

Mixture for texturing paper

Treatment of different surfaces

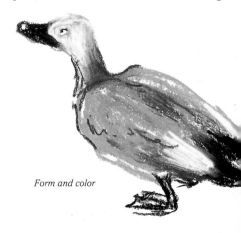

Form and color

IMPASTO Dense application of pastel.

LIGHTFAST Colors which will retain their original strength of tone and hue over time.

MORTAR AND PESTLE A bowl and grinding tool used to reduce pastel sticks to a powder for reconstituting pastel fragments into new pastels and for dry wash techniques.

MULLER Glass grinding tool used for the purpose of grinding and mixing pigments on a ground glass slab.

OIL PAPER Textured paper coated with an oil-resistant primer, used for oil pastel work. Particularly suitable when white spirits or turpentine are used, as the primer protects the paper from their detrimental effects.

OIL PASTEL Pastel bound by oil as opposed to gum. The oil gives this type of pastel a slight transparency and a strong adherence to the support. It comes in a less extensive range than soft pastels.

OPTICAL MIX When small areas of color juxtaposed to each other appear at a certain distance to merge and become a third color; i.e., red and yellow dots will appear to mix and become orange.

PASTEL PENCILS Similar to soft pastels only slightly harder and encased in wood. Suitable to drawing and detailed work. Also known as colored charcoal pencils.

PIGMENT Color in its raw state, used in the manufacture of artists' materials.

SGRAFFITO The technique of scratching lines in a surface application of pastel. The lines reveal the original color of the support or an underlaid layer of pastel.

SCRATCHING OUT The technique of making alterations using a blade to scrape away the pastel from the surface of the support.

SCUMBLING A technique of layering colors by means of a light application of the side of a pastel, which allows some of the support or previous application of pastel to show through the new application of color.

SOFT PASTEL The original and most common form of pastel. The weak solution of gum used in their manufacturing ensures a very soft texture so that they are the most suited to painting techniques.

SPIRITS White spirits or turpentine are used to dissolve oil pastels to create a wash.

STIPPLING The technique of applying colors in small points using a stabbing and dotting motion with the tip of a pastel.

SUPPORT The surface you choose to apply pastel to, e.g. paper, pastel board, or canvas.

SPARKLE The term used to describe the effect of an irregular, broken application of pastel on a support that contrasts with the tone or hue of the applied pastel.

TINT The degree of reduction of a color toward white as chalk is added to the original coloring pigment. Soft pastels have up to 8 tints of any one color.

TONAL KEY The degree of light that dominates a subject; i.e., a high tonal key would be a very bright subject, such as a beach in full sunlight.

TONE The degree of light reflected from a surface.

TOOTH OF PAPER The grain of the paper which holds the pastel pigment.

TORTILLON A tight twist of paper, shaped and sized like a pencil, which is used for blending pastel into a support.

TRAGACANTH The particular gum recommended as a binder for soft pastels.

WARM COLOR The colors between red/purple and orange/yellow on the color wheel are considered warm, although every hue has a warm – slightly redder – version.

WASH A dilution of color created by grinding the pastel to a fine powder and dispersing it across the support by means of a brush or cotton ball. Alternatively, using a brush and water, or turpentine in the case of oil pastels, to disperse the pastel in the manner of a watercolor wash.

WATER-SOLUBLE PASTEL A recent innovation, this type of pastel functions like an oil pastel in a dry state and is then reworked using a brush and water to convert the pastel lines into a wash of color.

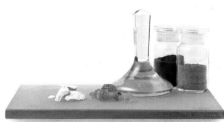

Pigment, chalk, and tragacanth

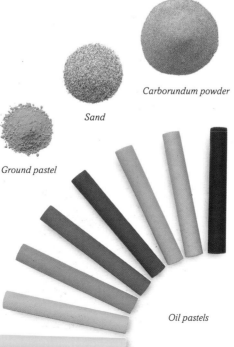

Carborundum powder

Sand

Ground pastel

Oil pastels

Art Deco teapot in pastel pencil

PASTEL DUST

Soft pastels generate a good deal of dust. Although the pigments that are used in their manufacture are carefully regulated so as to be nontoxic, it is still best to avoid inhaling the pigment powder as far as possible. Working outdoors presents no health risk. If you are working indoors, however, make sure that the room is well ventilated. Tap or blow away any excess powder from your painting and vacuum the area if it seems to be getting particularly dusty. You might prefer to use a drop cloth and shake it outdoors after you have finished working.

INDEX

ACKNOWLEDGMENTS

Author's acknowledgments
My sincere gratitude is extended to Emma Foa, my co-author and editor, for her constant guidance, good humor and professionalism, and to Gurinder Purewall for her lucid, imaginative designs which give clarity to these pages. Also to Sean Moore for giving me the opportunity to share in the cooperative endeavor of producing the book.

Picture credits

Key: *t*=top, *b*=bottom, *c*=center, *l*=left, *r*=right, *a/w*=artwork

Endpapers: Tamar Teiger; *p2*: Paul Lewin, *Cape Coast*; *p3*: Rosemary Saul; *p4*: Michael Wright; *pp6/7*: all, Sue Sareen; *pp8/9*: Bassano, Louvre, Paris/Réunion des Musées Nationaux; Carriera, Academia Venezia/ Scala; La Tour, Louvre, Paris; Chardin, Louvre, Paris; Millet, Glasgow Museums: The Burrell Collection; *pp10/11*: Degas, Louvre, Paris; Cassatt, Museum of Art, Dallas/Visual Arts Library; Redon, reproduced by courtesy of the Trustees, The National Gallery, London; Picasso, Musée Picasso, Paris, Réunion des Musées Nationaux, © DACS 1993; Kitaj,

Marlborough Fine Arts; *pp18/19*: all, Rosemary Saul; *p21*: *a/w* Sharon Finmark; *p23*: Redon, Private Collection/ Visual Arts Library; *pp26/27*: *a/w* Jane Gifford; *p30*: Manet, Ancienne Collection Brame et Lorenceau/Giraudon; *pp34/35*: *a/w* Ian McCaughrean; *pp36/37*: all, Jane Gifford; *pp40/41*: all, Ian McCaughrean; *p57*: Aghajanian, The Kerlin Gallery, Belfast; *p64*: Kitaj, Marlborough Fine Arts; *p71*: *bl* Phil Gatward.

Dorling Kindersley would like to thank: Cornelissen & Son Ltd, London, and Winsor and Newton for kindly supplying the artists' materials used in this book.

Additional photography: Philippe Sebert: *p9: tl, c; p10: t.*